MW01493338

HAUNTED SUMMERWIND

HAUNTED SUMMERWIND

A GHOSTLY HISTORY OF A WISCONSIN MANSION

DEVON BELL

Haunted America

Published by Haunted America
A Division of The History Press
Charleston, SC
www.historypress.net

Cover photo by "OMW."

First published 2016

ISBN 978-1-5316-9992-5

Library of Congress Control Number: 2016938321

This book is dedicated to my wonderful grandparents Curt and Veda. When I needed a sanctuary and unconditional love, you both were always there for me. I am proud to be your eldest granddaughter.

I love you both very much.

Dev

CONTENTS

FOREWORD

There is something enchanting and inviting about Wisconsin's Northwoods, and somehow it's appropriate that it provides the location for what is reputed to be Wisconsin's most famous haunted house. These woods and the lakes that dot northern Wisconsin were once home to a number of Indian tribes and various wildlife; today, they are home to seasonal cabins for winter sports enthusiasts, hunters, fishers and folks on vacation who are looking to just get away from the hustle and bustle of the cities. It is also home to a past that is as well encompassed as the trees and forests in this region. Several crime barons used to frequent the area (John Dillinger once hid out in Manitowish Waters and narrowly escaped in a shootout with the Federal Bureau of Investigation). Native Americans fought for years over the land. Today, there is still the occasional dispute with neighbors over where one's property line ends and another's begins (but that doesn't always get ugly). So it's only appropriate that this provides the location of Summerwind Mansion.

I first learned of Summerwind at age eleven, when I read my mom's copy of *Haunted Heartland* by Beth Scott and Michael Norman. At the time, I myself was living in a haunted house, and it shared a handful of similarities to Summerwind. One major difference, however, was that our ghost was friendly (but unintentionally scary to us), and Summerwind's ghosts (note the plural) were not. As an adult, I used some of my free time to research Summerwind and examine the similarities of my own experiences in that house of my youth (even though I only lived there for one year). I became more and more fascinated by the history, aura and legend that was Summerwind. Although the fabled mansion was destroyed (most sources

cite lightning) in 1988, there were still ruins of the property remaining—according to some Internet stories, so were the ghosts that haunted the land.

The overcast morning of June 28, 2008, found me guiding my Camry up the steep hill toward Summerwind's remains. To my advantage, I was armed with permission from the (then) owners, my disposable Kodak camera, bug spray and Sinatra's "Summer Wind" running on the CD player. Only a swarm of mosquitoes and a frightened doe stood guard against the ruins as I arrived. When I left thirty minutes later, I had no doubt that something unusual had happened, but I didn't know what. One week later, when I returned from my trip and got my photos developed, I got all the evidence I needed. But my stories are for another time.

I met Devon and her husband, Tony, on Chad Lewis's Unexplained Research message boards prior to their own venture to Summerwind in 2010. As paranormal/historical researchers, they do a remarkable job with their research and their work, and they certainly form a tandem—they know what they are looking for and will root around until they find it. Tony works wonders with a video camera and production, and Devon is an amazing storyteller who will enchant you from beginning to end. It's certainly fitting that you are reading her book and allowing her to be the one who tells you this story.

Although none of us has returned to Summerwind since our original visits, our own experiences continue to mystify and intrigue us to this day. It is through that curiosity and intrigue that Devon presents this book. While mostly dedicated to Summerwind's past, there are stories from people of various backgrounds and all walks of life. Each has his or her own story to tell, all with one common denominator: the mystery of Summerwind. From its origins as a summer retreat for a Chicago business tycoon who became secretary of commerce to sitting empty for years, a family's few months of horror eerily reminiscent of *The Shining*, a proprietor's folly searching for a colonial American deed, the squabbling of friends over a house with no future, the destruction of a once-glorious property and the reputed hauntings that continue to this day, Summerwind is full of surprises.

So please, hum a few bars of the song (rendition doesn't matter), turn on a reading lamp, light either a lavender- or lilac-scented candle, stretch out and allow yourself to be enchanted by the aura and mystique of "my fickle friend, the Summer Wind."

—ADAM BAUER
Summerwind enthusiast, Cedar Rapids, Iowa,
January 2014

"SUMMERWIND"

Summerwind Mansion, You disappeared from view, Should we believe The story that was told, Could really be true?

It's all too clear They were afraid of the night! Or was it the ghost that brought fear, That made them uptight?

Perhaps it was the murky shadows, That form when the moon is full? Too bad! Now there's no reflections, To be found in the pool!

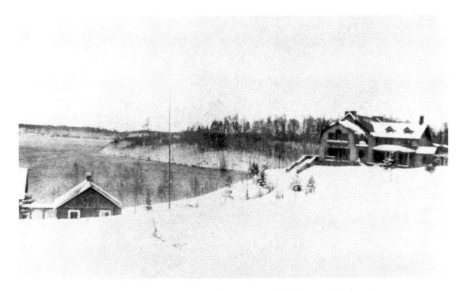

LaMonte Estate West Bay Lake, Cisco Chain, circa 1925. *Courtesy of Adam Bauer.*

Lightning and Fire, Has ended your North woods reign. How foolish for them to think, Your absence can end their pain!

What more can be told, Of a building once so fine? Hastily removed from the Calendar, On which we innocently, record time.

Stand for a moment, Beneath that old Jack Pine. All that's left to protect Summerwind, From the Evil mind!

Too late to appeal, To those that came at night to steal, From this helpless Mansion by the Lake. Just one question, Was the plunder worthy of the take?

Like the story of the Phoenix of old, Will Summerwind Mansion accomplish, Something equally bold? The original plans in detail so fine, Could replace that building, In a very brief time!

But for now we may all wonder, When there's a rumble of thunder, And we turn away from the lightning flash, Protecting our ears from its deafening crash, There is that boat, Entering the harbor, Can that be, Jonathan Carver?

—Wolffgang Von Bober, 1996

ACKNOWLEDGEMENTS

I would like to start out by saying thank you to my wonderful husband of seven years, Tony. You are my best friend and greatest supporter and always encourage me to delve into anything in which I have an interest. Thanks to my parents, Lance and Peggy, who have always told me that I can do anything I set my mind to. My friends and family are all great supporters, and without their encouragement and frequent input, I probably never would have started writing.

Thank you to Ben Gibson at The History Press for giving me this wonderful opportunity. During the process of writing this book, I had many contacts who helped me in my research, whether it was historical or paranormal. I would like to thank Callie Bernier for donating her school paper on Summerwind, author Tom Hollatz for his two amazing and incredibly insightful books containing information about Summerwind Mansion and the late author Wolffgang Von Bober for writing the now infamous *Carver Effect*. I'd like to also thank intuitive Wendy for her friendship and feedback when we visited the old mansion ruins, paranormal authors/researchers Chad Lewis and Terry Fisk for their informative books and, very importantly, my good friend Adam Bauer, who so graciously accepted my request of writing the foreword for this book, as well as for contributing so many files on Robert P. Lamont and the mansion.

I very much appreciate all the individuals from whom I received historical photographs. I'd like to say thanks to "OMW" for contributing some photos of Summerwind when it still stood; Adam Bauer for donating some photos of

the mansion; Joshua Chaires, who donated photos of the original blueprints to the house for this book so readers could see for themselves the magic that was to be Summerwind before it was built; and, lastly, Todd Roll, who has been generous and kind in allowing me to use his photos of Summerwind.

I also want to say thank you to all those individuals who took the time to share either historical information or their own personal stories via the Internet that are referenced in this book. Many people helped me in my quest during this process, and I apologize if I have neglected to thank someone of the utmost importance to me. If this is you, please accept my deepest apology and know that I am so very grateful for all the help that went into the creation of this book.

PREFACE

It was a house without kindness, never meant to be lived in, not a fit place for
people or for love or for hope. Exorcism cannot alter the countenance of a house;
Hill House would stay as it was until it was destroyed.
—Shirley Jackson, The Haunting of Hill House

There's no place like home." This famous line from the beloved classic film *The Wizard of Oz* is known by most worldwide. When Dorothy utters this statement in her innocent hope and clicks those ruby-red shoes together, we all truly believe in miracles. I close my eyes now and think back to the house where I grew up and spent most of my childhood running around and playing. I still dream of that house and long to walk through it again. I guess that sometimes we can actually have a long-term connection or bond with a place that we hold dear. So I know what Dorothy is talking about when she vocalizes her deepest wish. To most, home is a place where you can sit back and relax. It's a sanctuary, and most feel safe inside, tucked away from the hustle and bustle of day-to-day life. Unfortunately, as you will learn, not everyone is as lucky as you or me. To some, a house is a place of darkness and torment. Upon arriving home, they hesitate to exit their car and nervously walk up the porch steps to the front door. They timidly reach for the door handle and for one instant imagine running away and never looking back. But where would they go? For them, any other place but their house is home. What awaits them when they enter inside? They must keep their wits about

them and always be on the lookout for anything strange and unusual. When they lie in bed at night, it's as if they are climbing into their coffin.

If a home or building secures a strong bond with a person, just think of when this building or house is evil. Is it possible that a home *can* be evil? Is it the spirit or spirits that haunt the halls that gives the effect that the home itself is bad? I'm not truly certain if a standing structure can be evil. It's true that some structures can be ominous or foreboding, but can an inanimate object really come to life and do harm to its inhabitants?

The case of the old Lamont Mansion, dubbed "Summerwind," near Land O' Lakes, Wisconsin, proves this theory, actually. Some really believe that the house itself came to life and terrorized any person who dared to live inside. Others think that the house was infested with horrible spirits of those who never let go and wanted everyone to feel their pain and torture from the other side. Then there are the skeptics who think that the only infestation was that of the many bats that used the old building for their permanent dwelling.

After four books completed, I was talking to my husband one day and asking him what I should base my next book on. He replied, "Summerwind." It was a wonderful idea, and I couldn't believe that with all the hype and popularity this place has, no one has ever written a definitive book on the history and lore of the home. I felt that it was meant to be, and I hope I have done a good job trying to make Summerwind Mansion come back to life.

Ever since I saw this particular location on an episode of Discovery Channel's show *A Haunting*, I have been intrigued by it, not only by the ghost lore but also by the history of what has now come to be called Summerwind Mansion.

Introduction

Speak only good of the spirits...
—*Wolffgang Von Bober, 1985*

Back in 2010, my husband and I, as well as a few friends, decided to venture up north to see the elusive, much-talked-about ruins of Summerwind Mansion. My husband, Tony, and I are historical/paranormal filmmakers and were then working on season one of a web series that we had launched with our company called "The Haunting Experiments." We wanted our first season finale to be really big, so we decided that Summerwind Mansion fit the mold perfectly.

Tony called up the then owner and obtained permission to not only visit the ruins (which are private property) but also film our short documentary there. We were all so excited, and I remember the trip taking forever. At first, we couldn't find it, but then we found a long winding dirt road that twists and turns farther back into the woods. I remember it like it was yesterday. We decided to pull into a driveway, and we happened to see a sign that read, "No Trespassing." We figured that we had found the ruins. I was already totally aware of what the old mansion looked like ever since it burned down back in the 1980s. But as we rounded the corner, there it was in all its dilapidated glory. This may come off a bit melodramatic, but I literally inhaled and held my breath when I first saw the two towering chimneys standing amid all the trees and rubble. I also remember pushing my foot down, almost like I was trying to slam on the brakes, even though I wasn't the one in the

driver's seat. I had this feeling of overwhelming panic. It was as if the ruins were saying, "Get out and stay out!" I have never had this reaction in all my legend-tripping days. That's why Summerwind will stand out for me for as long as I live.

There isn't as much history as there is ghost lore, but in my opinion that is quite common. As the years go by and the ghost stories are passed from one generation to the next, it's almost as if the attraction strengthens. Summerwind Mansion is larger than life, and even though it's mostly ruins scattered about, it still has a commanding spirit about it. I felt like I had no choice but to completely respect it while I was there, making sure not to trample about. I treaded with care, as did my friends, and together we explored the grounds. I have often heard that this location has a kind of hold over people. When the mansion still stood but was unoccupied, some individuals would state that it was almost like the house was calling to them; they felt sorry for the home because it stood alone and had no one to fill its many rooms. Like the siren calling mysteriously and seductively to the sailor, these crumbling ruins have begged for attention and reached out to pluck at the heartstrings of many. Some have stated that they had no choice—the ruins called to them, and they had to answer; they couldn't turn and walk away. Perhaps if I could have visited when it still stood I would feel differently, but I can tell you that I had the opposite feeling while there. I felt strongly that we shouldn't be there, that we had no right to be there. Whichever way others have felt, it seems as though this house (or even the ruins now) has some supernatural power over people. This begs the question: how or why does this location have the power to affect human beings this way?

Haunted house stories are a dime a dozen. However, what makes Summerwind stand out is the unnerving history that goes with it. The grounds have a few famous names attached, like British explorer Jonathan Carver, and the man who built the mansion for a summer retreat home, Robert Patterson Lamont, who at the time was the secretary of commerce during the administration of the thirty-first president, Herbert Hoover. Even former president Warren G. Harding, who was our twenty-ninth president and served between 1921 and 1923, stayed in one of the twenty rooms within the mansion at one point in time.

Lamont, along with his wife, had a terrifying experience in this house when they encountered an angry spirit one night while at the dinner table. The house has since showed its true colors to other families who dared to live there. There are tales of being cursed by this property if you take a souvenir from the ruins and bring it home as a keepsake. One of the

most popular stories is that of a mysterious deed that belonged to explorer Jonathan Carver. This important document was said to have been put in a box and sealed in the foundation of the mansion. The mystery deepens with Raymond Bober, who was very interested in the property and claimed that the spirit of Carver was haunting the home and would not rest until the deed was given back to him.

This is no ordinary "bump in the night" haunted house. Even though it has since burned to the ground, this homeplace still has a powerful presence and hold over everyone who learns of its disturbing past. My fervent hope for you readers is that you find the history and ghost lore as interesting as I do. I hope to show you different sides to this place—some light and cheerful, as when the former mansion stood in all its glory, and some cast in darkness, as when several individuals were tormented by whoever or whatever inhabits this area. If you are brave, I welcome you to join me now. Just be on your guard, for if Summerwind beckons to you, you may want to think twice before you invite it in.

FROM HUMBLE BEGINNINGS

The simple truth is that you can understand a town. You can know and love and hate it. You can blame it, resent it, and nothing changes. In the end, you're just another part of it.
—*Brenna Yovanoff*

Some people say that you are a product of either your generation or where you grew up. Here in the Midwest, there are small rural communities scattered just about everywhere, and like the quote by Brenna Yovanoff, sometimes you love it and sometimes you hate it. When it comes to the old Lamont Mansion—or, as locals in the Land O' Lakes area like to call it, "the haunted house"—townsfolk are most likely split down the middle about the reported lore: some embrace it; others denounce it and pretend it doesn't exist.

The town of Land O' Lakes was formerly known as Stateline and Donaldson and is an unincorporated town within Vilas County. The community is located along the state line of Michigan, so I had to chuckle when I read about its former name. I think Stateline was quite fitting, actually. I found the following historical information on the official Land O' Lakes Historical Society website: "The economic origins of the town of Land O' Lakes (originally Stateline) go back to the 1870s when the Rudolf Otto mill, one of the best single-rotary mills in Northern Wisconsin, was built. It was succeeded by the Mason-Donaldson Co. Mill formed in 1905. The Mason-Donaldson Mill gave its name to the town of Donaldson,

located along highway B just west of the town of Land O' Lakes." The town of Donaldson had a school and a community building that also served as a church and meeting hall, as well as several homes. Many of these homes were later moved closer to the railroad tracks as the town of Stateline became more prosperous. When the Donaldson Mill burned down in 1908, townspeople decided not to rebuild their community; instead, they moved the town east to its present location under the name of Stateline, due to the fact that it rested right on the line between Wisconsin and the Upper Peninsula of Michigan.

A school was built in the town of Land O' Lakes around the turn of the century, and then in 1931 a more modern school was built near the Land O' Lakes Town Hall. This town was originally part of Lincoln County in 1882, but in 1885, it became part of Oneida County. In 1893, it was included in Vilas County. According to the Land O' Lakes Historical Society website, "At one time it was said that Highway B went through timber so thick that one '40' (forty-acre parcel) produced one million board feet of lumber. This rich resource led to the development of area logging camps, including Bent's Camp, located on Mamie Lake, established in 1893; the Presque Isle logging camp located 15 miles North of Boulder Junction, Wisconsin, established in 1914." In fact, there were several logging camps and tourist retreats there as well, and many flocked to the area not only to make a living but to also get away from their busy lives in the city. The lush landscape and bountiful wildlife made this area very attractive to a variety of people over the years.

A perfect example of this is Robert Patterson Lamont. He was a wealthy man who resided in Chicago. He and his wife were attracted to the Land O' Lakes area because of its beauty and the calmness it had to offer. So, Lamont decided to construct a summer retreat home and set about making plans. But I feel as though I'm getting ahead of myself here.

ANOTHER BRICK IN THE WALL

I first heard about Summerwind when I saw a rerun episode from the Discovery Channel show called *A Haunting*. Like many of you, I was totally enamored of this place, even though it has since burned to the ground. I didn't care. My curiosity grabbed me by the shoulders and wouldn't let go.

First, I'd like to give you readers a little back story on my husband and me. In 2008, I got my husband, Tony, into legend-tripping. From there, we purchased an audio recorder and started visiting locations and taking audio or EVPs (electronic voice phenomenon). Tony had always been interested in film and had always wanted to make video. We decided to combine our interest of the paranormal with film, and the end result was the Haunting Experiments. Starting in 2009, we launched our film group and started to visit various locations, filming short documentaries for which I wrote narrations. We showed the reportedly haunted spots, talked a bit about them and on certain occasions had reenactments as well. Then in 2010, we decided to make a web series that was to consist of about nine to ten episodes that ranged from five to ten minutes apiece. I was struggling with our season finale for the first season because I wanted it to be a popular place that would really make for a fitting close to our first season. Then I thought of the old ruins up north and smiled to myself. Summerwind!

I contacted a friend and obtained the then owners' phone number. Tony called the owners and spoke with them, asking permission so that we could not only visit but also film the grounds for our short documentary. They were very nice people and agreed right away. They even said that

if they were going to be up in the area when we were going, they would have met us. However, it was off season for them to be there, so we never got to meet face to face. It was September 15, 2010, when we piled into friend Jesse's white Oldsmobile Alero. The weather was cold and damp, with the changing of the seasons coming up fast. It's typical in the month of September to have chilly, rainy days here in northern Wisconsin. Our group consisted of Jesse (the driver and road-tripping extraordinaire!), friend and intuitive Wendy, Tony and myself. We left very early in the morning and started off eagerly on the four-hour trip up through the Northwoods. Halfway through the trip, I started getting a bit restless and turned to look outside as the water slowly drizzled in zigzag patterns down the side of the passenger window. I blew out a frustrated breath and turned to Wendy as we started to again make conversation.

The drive up went smoothly, but finding the mansion was a different story. The reports I read online and in books from different people who have visited the ruins of the old mansion all pretty much state the same thing: they got lost trying to find the place. It's off a dirt road, and there are many cabins back in the woods, so it's confusing. It was the last road on our checklist that we hadn't driven down, and we had driven too far to give up! As Jesse slowly made his way down the dirt drive, all of a sudden quite quickly I was able to make out the two tall skeletal arms of the old chimneys that used to be a part of the house. I inhaled sharply and pushed my right foot down, pressing it to the floor of the car as if I was trying to slam on the brakes. I can honestly say that the sight took my breath away and terrorized me at the same time.

Jesse pulled the car to a stop, and both he and Tony practically tumbled out of the car, so eager to go explore. I stretched, giving myself a minute to take everything in, and then turned to Wendy, who was sitting next to me in the backseat. I have only seen one person in my life get that lifeless gray color, but now I can say I have seen two. There was a horrible gray hue to her skin, and I asked her if she was okay. She then said to me that I should get out and go take a look around. She mentioned she felt sick to her stomach and that sometimes certain locations gave her that feeling. She hesitated, and after she reassured me that she was all right, I got out of the car. I was dying to go run around and start snapping photos with my camera. I found Jesse, and together we walked to the back terrace, where there is a stone wall with pavement. I couldn't find Tony for the longest time because he was off trying to figure out which angles would be perfect to film, and once he's in that zone, I know to just leave him be.

A few minutes after we stood on the back deck, Wendy slowly made her way over to us. Her color was looking much better, and she went off to do some exploring of her own.

I recently found a blog online by "Savannah Rayne," who knows Wendy and interviewed her about her trip and experiences at the Summerwind site. I remember talking to her about everything once we got in the car to leave but never wrote anything down. So I want to quote Wendy from this blog, where she was asked about her Northwoods adventure. The blog is dated October 17, 2011: "I was invited to Summerwind for a day and couldn't say no. Who could, I mean it's the most haunted place in Wisconsin, come on…I'm so there! When we turned the car down the driveway I began to feel flu like sick. I had to jump out of the car right away to ground and shake off the sick feeling. As soon as I got out and took a few steps from the car, as the team walked away to find a place to set up for filming, I heard a male voice say, 'The deed is not here.' So I called out to Devon and said, 'Hey, what does "the deed isn't here" mean?'" I then explained to Wendy a bit about this infamous deed that belonged to British explorer Jonathan Carver and the rumors that the

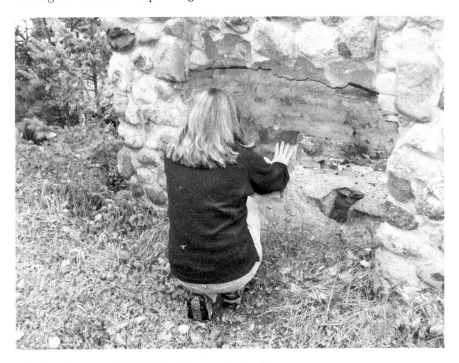

Wendy at Summerwind, 2010, checking out the fireplace.

deed was buried in the foundation of Summerwind. Wendy also went on to state on the blog, "While we were there we had a few experiences of communicating with ghosts. A few weird smells going on and a few strange sounds were heard." When we first arrived, Wendy put her hands out in front of one of the old fireplaces and stated that she felt warmth emanating from it. Her hands even started to thaw from the cold.

She also stated that when we walked into the basement area, she saw a little girl playing. Wendy noted the young girl didn't say much and didn't stay around that long. Then, later, when we were all up standing on the patio, Wendy told me that she talked to a woman that presented herself as the governess of the mansion. This spirit woman offered no name but did go into detail about doors opening and closing and a bad energy about the place. According to Wendy, the spirit of the governess stated, "You are of the light, child. Your vibrations are too high for that which is here. It will not show itself to you, you are of the light." What was "it?" An angry spirit or some source of negative energy that this ghostly governess knew would upset or overwhelm Wendy? Wendy also saw a brief vision of Native Americans and the land being important to them. On that same note, I have often wondered if the negative energy or spirits connected to the spot Summerwind stood are possibly older than we all realize. Perhaps they date back to when the Native Americans inhabited the land, before early white settlers came.

I remember having a really good conversation with our friend Jesse. We were discussing old buildings and how it's a shame that so many are left abandoned; they end up falling down or are leveled. Until I had that talk with him, I never knew that he had an interest in that sort of thing. One of the other conversations I had was on my cellphone while standing on the back terrace. Unbelievably, I had signal there that day. My dad has a cabin up north, not quite that far but probably within an hour's drive from the ruins. I recall telling him that I would call once we got there. I stood there surrounded by the death and decay of a former mansion. Some viewed it as almost a living monster, some were enticed and some were even driven to madness by this very place. As I stood on the wreckage and talked to my dad about the fall colors, the damp cold, how peaceful it was, he started telling me about an old retro table he had found at an estate sale that he thought Tony would like. I look back on that and laugh now. How odd that conversation was, but at the same time, I learned that if you let the aura and enigma of Summerwind hold you by its powerful grasp, it will definitely get to you. The mind

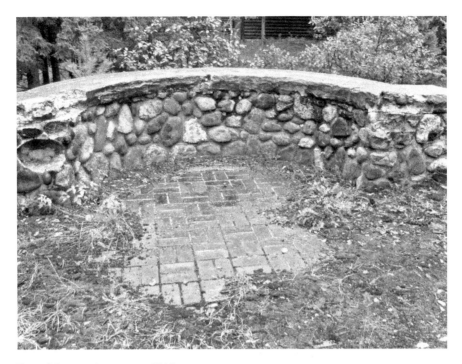

Part of the mansion terrace, 2010.

plays tricks and can make us see or feel what is not really there. Make no mistake: I am not saying that the land that once held Summerwind isn't haunted. I felt something there that rainy day in 2010, but I can't say for sure what it was. Then again, the paranormal is also the unexplained, so I learned to embrace the fact that I will probably never know what it truly was.

Even more odd than the phone call to my dad was the visitor we had that day. Tony and I have another friend named Jesse, and he was in search of the ruins that day as well, but for different reasons. He found out a few days before we left where we were going and called Tony immediately. He stated that he had a friend who had visited the old mansion ruins months ago and had taken a brick home from the foundation as a souvenir. Shortly after she arrived home with it, she started having bad luck. He didn't go into detail, but from what I remember him telling me, she gave the brick to him because he is a total skeptic when it comes to the paranormal. So he took the brick and thought nothing of it. Then *he* started having bad luck, like problems in a relationship, issues with where he lived and just

feeling as if a black cloud was constantly over his head. He told his friend about it, and she said that was part of the lore attached to Summerwind Mansion. In the past, people have taken something like a brick from the site; when they got home with it, bad things begin to happen. She told him that he needed to take the brick back to its home. After learning that we were venturing that way, he suggested he meet us there. However, he didn't show up in a car; he showed up in his kayak. He decided to kayak all the way across West Bay Lake and then hoofed it up the tall hill, where he met us at the site. I took one look at him and shook my head, laughing. He then pulled out the "bad omen" from his backpack and held it out, asking me where he should put it. I told him that since he didn't know exactly where it came from, he should just throw it into the "bowel" of the ruins, which was the center and had originally been the basement. So, with a quick throw, the brick went tumbling into the abyss of ferns and weeds. That Pink Floyd song "Another Brick in the Wall" was playing in my head awhile after he tossed the souvenir away. Let this be a warning to all who think to visit the ruins: you might not want to take anything like Jesse's friend did if you are feeling a bit superstitious. I imagine that the old crumbling remains do not like being robbed and are fiercely protective over what is left of the old estate.

I want to end the retelling of my adventure to Summerwind with one last experience. First, I want to state that I never saw a spirit, was attacked or was even playfully shoved. That day at Summerwind, I felt something. I was near Wendy when she was exploring one of the old chimneys and felt a few light tugs on the back of my necklace. I actually had on a necklace that I was told had protective stones, and even though I am not a very superstitious person, I went ahead and put it around my neck before leaving that day. I wonder if it was the spirit of the little girl seeking out my attention or if it was an angry spirit telling me it was offended by my necklace. I have to admit, that day the chilly weather didn't get to me, but the restlessness of the Summerwind site turned my blood ice cold.

After a few hours of visiting, our time came to an end. I felt a sense of loneliness there—maybe pain or longing. Reflecting on my experience visiting the site, I am honestly split down the middle. On one hand, I felt excited and the rush of adrenaline because it was the deserted and creepy ruins that made the atmosphere spookier, which was perfect for legend-tripping. On the other hand, I truly felt sorry for the ruins. It almost appeared as though it was sad and forlorn, having to rot away year after year in utter isolation. It stands as a shell of what it once was, with no life except for the occasional

Our group. *From left to right*: Wendy, Devon, Tony and Jesse.

wildlife, vandal, legend-tripper or paranormal investigator. There's no one there to care for the grounds, and it's all overgrown. It sort of reminded me of a lost kitten; it couldn't seem to find its place in this world now. Sometimes I wonder if Summerwind, be it mansion or ruins, took on a real human spirit. So many people state that they feel strong human emotions for it, and I can understand where they are coming from. In my opinion, that's the strongest hold that anything, living or dead, can possess.

THE MAN BEHIND THE HOUSE

Washington, D.C.
February 27, 1929

Robert P. Lamont
30 Church Street
New York City

I have concluded that it is necessary in national interest to draft you into the Cabinet. I understand through Mr. Shaw that this is agreeable to you and I have decided to present your name as Secretary of Commerce STCP. I wish to express my deep appreciation for your willingness to enter national service.
—Herbert Hoover

This letter was sent by Mr. Herbert Hoover to Mr. Robert P. Lamont via Western Union on February 27, 1929. How proud and excited Mr. Lamont had to have been to receive such wonderful news. He was stepping into the next chapter of his already accomplished life.

In 1916, Robert Patterson Lamont, who was later to become the secretary of commerce under President Herbert Hoover, was looking for the perfect location to build a summer retreat home for his family to escape to every year. Once his eyes beheld the West Bay Lake Resort, he was smitten. Perhaps this area had a strong hold on Lamont, as it has for dozens of others over the years. I don't blame him for falling in love with

the area, for it was nestled on the shores of West Bay Lake, and he could only imagine his future summer home catching the smooth, cool breeze from the lake and the scenic, serene views from all angles. At the time, Mr. Lamont was working in Washington, D.C., and this home would be a perfect haven to escape his very stressful life.

Robert Patterson Lamont was born in Detroit, Michigan, on December 1, 1867, to Robert Lamont (born in Scotland) and Isabella Patterson (born in Canada). I found a unique description of Lamont in an article sent to me by a friend. It was an article found in the *New York Times Magazine* from Sunday, April 14, 1929, and was written by Anne Hard:

> *I know as I write these words they may be discounted by some one as the enthusiasm of over praise. But I dare any one who takes issue with that statement to discuss "Bob" Lamont with anyone who knows Chicago. When you have learned that fact it is easy to account for Mr. Lamont's appearance, and perhaps also for much of his temperament. He is tall, and after sixty years still well set-up and thin. He has an air that would carry the green-and-blue check of the family tartan and a bonnet slantwise on the top of his sandy hair. Above all, his eyes are of that bright blue which flashes only for a northern people. Be that as it may, there is the intellectual energy of kirk and university in Mr. Lamont's broad, high forehead, the sinew of porridge eating ancestors in his brawny frame and the love of golf in his heart. He belongs to four clubs in the neighborhood of Chicago.*

It sounded as though Mr. Lamont had a great passion for golf, as the author continued, "For him, however, golf is not merely a 'favorite game.' It is the complete sum of his outdoor interests."

Lamont attended college at the University of Michigan and graduated in 1891 with a bachelor's degree in civil engineering. He then found work as an engineer at the 1893 World's Columbian Exposition in Chicago, Illinois. On October 24, 1894, Mr. Lamont wedded Helen Gertrude Trotter, and they went on to have three children: Robert Patterson II, Gertrude and Dorothy.

In 1897, Lamont was hired by the company Simplex Railway Appliance as first vice-president. In 1905, this company was bought by American Steel Foundries; however, Lamont remained vice-president. Then in 1912, he moved up the corporate ladder to become the company president, a position he held until his Hoover administration appointment in 1929.

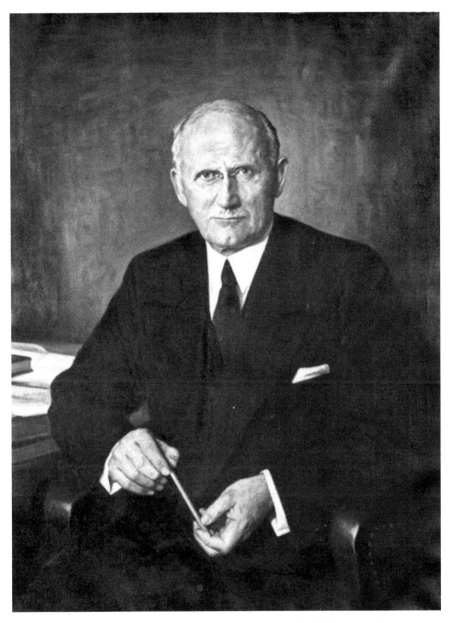

Portrait of Robert Patterson Lamont. *Courtesy of Wikimedia Commons.*

Lamont was secretary of commerce from 1929 to 1932, whereupon he resigned in order to become president of the American Iron and Steel Institute, remaining employed with this company until 1934.

On February 20, 1948, at about 5:00 p.m., Lamont passed away at the age of eighty after suffering from a long, ongoing illness. Mr. Lamont left behind his wife and three children. According to an article from the *St. Louis Post-Dispatch* dated February 20, 1948, "Funeral services will be tomorrow in St. Bartholomew's Protestant Episcopal Church (Harkness Chapel). Survivors include his wife, Mrs. Gertrude Lamont of Falls Church, VA; a son, Robert Patterson Lamont Jr. of Thiensville, Wis; and two daughters; Mrs. Matthew Jones of Washington, D.C; and Mrs. Chauncey Belknap, of New York, at whose home Lamont died." I was so grateful for friend Adam Bauer, who sent me a packet of information, including this article on Mr. Lamont's death. When searching on the Internet, all the sources I found claimed that he died in Chicago, Illinois, when he did not. He passed away at his daughter and son-in-law's home in New York.

Lamont's life had a dose of mystery to it, with the alleged haunted house he claimed as his beloved summer retreat home. However, in death he is even more mysterious. I had searched high and low to try to find his final resting place, but to no avail. I found a few online sites that stated that his burial location is unknown. Then I found a book entitled *Where They're Buried: A Directory Containing More Than Twenty Thousand Names*, and under the category for "Secretaries of Commerce," there is a Robert P. Lamont listed—it states that the year of his birth is not known, the year of his death was 1928 and that he was cremated; however, the location of his ashes is either not known or undisclosed. The issue with this is that the year of Lamont's death was 1948, not 1928. Over the years, I have learned in conducting research, particularly historical research, that dates are not always correct. Perhaps Lamont really was cremated, his ashes scattered in some unknown, private location, and his death year had an error. It makes sense, as that single-digit error could be an easy one to overlook. However, I was in for some luck when I referred to another article in that packet of information.

I was about to give up, but a friend sent me an article that was published in the *New York Times* on February 22, 1948. It was titled, "Rites for Robert Lamont" and stated, "Cremation took place yesterday at Ferncliff, N.Y., Cemetery. Burial will take place at Detroit at the convenience of the family, two of whose members are ill and could not attend the service."

So the mystery of Robert Patterson Lamont's final resting place was now concluded. He was cremated, and his ashes were given to his family. I haven't been able to find a marker or anything of the like at a cemetery, so I figure either the family scattered his ashes or they are still in the hands of family members. But the secrets of Summerwind Mansion, a home in which Lamont took great pride, are still a mystery. The secrets filled in every crevice of the now crumbling foundation.

THE BIRTH OF SUMMERWIND

Every building or structure begins with a simple design and a brick or piece of wood. Summerwind was already born inside of Robert P. Lamont's mind. But what, if anything, existed before this infamous mansion was built?

In the early 1900s, the area of Land O' Lakes was populated with many well-to-do families. They were looking for the perfect retreat away from their hectic, busy lives. They were away from the city, and the Northwoods, to them, was the ideal world in which to become immersed. There were many lodges and cabins that were built for these individuals, and the area was full of activity. There was a fishing lodge and several cabins that overlooked West Bay Lake, and it was here that Lamont envisioned his tranquil summer mansion. It was situated on the southern end of the Cisco Chain of Lakes and had beautiful scenery at every angle. I'm sure that Robert Lamont imagined sitting out on the terrace overlooking the lake, feeling the cool breeze on his skin, breathing in the clean air and hearing the gentle lap of the water against the shore.

But before Robert Lamont bought the property, it was owned by a gentleman by the name of John H. Frank. Frank was born in Akron, Ohio, on May 30, 1871. His parents were Martin Frank and Jennie (Allen) Frank. In the year 1877, his family relocated to the state of Michigan. By the age of twelve, John had started working on a farm and was making his own money. He stayed on at the farm for about three years and then headed to Washington State. There he learned to

be a blacksmith and ended up in Grant Pass, Oregon. Several years later, he went back to Eagle River, Wisconsin, and worked as a blacksmith in lumber camps and sawmills. However, he eventually relinquished the blacksmith trade and settled on land that was nestled by the beautiful West Bay Lake. Mr. Frank then turned his homestead into a summer resort that he named "West Bay Lake Resort." His resort consisted of a hotel and four cottages, and Frank maintained them all until he sold the property to Robert Lamont. Before John Frank retired, he drove by motor car to California and Washington, and he remained on the Pacific coast for one year before returning back home via motor car. As for Robert Lamont and the property, well, this is where the history gets very odd and mysterious.

In 1916, Lamont had purchased the property from Mr. Frank and hired an architectural firm out of Chicago, Illinois, called Tallmadge and Watson to design the home and make it come to life. There are reports that the original fishing lodge was added on to, but some say it was leveled and the mansion was built in place of the lodge. According to every source I have come into contact with, the building took about two years to complete, and when it was all said and done, there stood a grand mansion with twenty rooms and several outbuildings. It was massive, elegant, larger than life and perhaps kept a sinister secret or two from all the individuals who resided within its sturdy walls. According to author Tom Hollatz, in his book *Campfire Ghost Stories*, the cost to

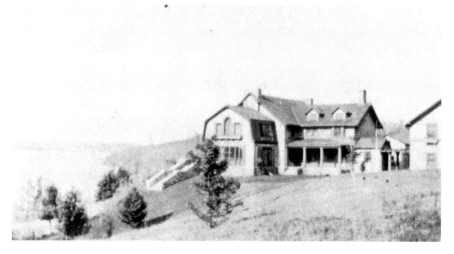

LaMonte Mansion West Bay Lake, Cisco Chain, circa 1925. *Courtesy of Adam Bauer.*

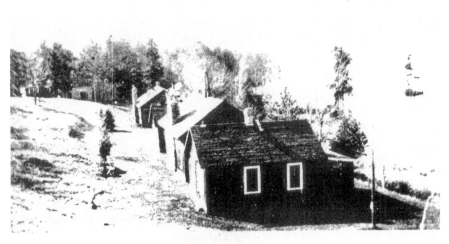

LaMonte Property West of Main House
West Bay Lake, Cisco Chain
Circa 1925

LaMonte Property West of Main House West Bay Lake, Cisco Chain, circa 1925. *Courtesy of Adam Bauer.*

build and totally complete the mansion back in 1918 was $125,000; just think of how much that would mean in this day and age. I also came across a flyer on the Internet that shows the Summerwind home as it looked back in the 1920s and 1930s, and above the photo, the brochure reads, "The great outdoors calls you to the most beautiful lodge on the famous Cisco Chain." Then, below the photo of the mansion, it reads, "Mish-Wa-Wak-Gan AND Prairie Moon Lodge, located at the Gateway of the Cisco Chain." The town name Land O' Lakes is printed at the very bottom of the flyer. It's very interesting that the mansion was being advertised and seemed to be one of the more popular rentals back in its prime! According to a man I will call "P.M.," "This image was from an exhibit I did for the Land O' Lakes Historical Society six or seven years ago on an area resort. In the 1930s, the Lamont estate became a resort called Prairie Moon Lodge, where one could rent a cabin or set of rooms for twenty or thirty dollars per week during the summer. A man named Keefer ran the resort, as well as a series of nearby cabins called Mish-Wa-Wak-Gan."

There are many questions as to why Summerwind Mansion was claimed to have been haunted. I often wonder if perhaps during the

era when British explorer Jonathan Carver was in the area, maybe there were small battles or arguments between him and the Native Americans. During the 1700s, they inhabited much of the land and might not have taken kindly to Carver coming through and disrupting their settlements. To date, I have not found any historical documentation regarding any skirmishes or fights between the settlers and the Native Americans of the area, but who's to say there wasn't some incident that happened that was never recorded? Not all of history is known, and some of it will probably never be known. The land where the ruins of the old mansion sit could possibly be littered with spirits or negative energy. It could be the outcome of something violent, it could be territorial or the land could be cursed. It seems as though after the mansion was built, there was uneasiness among the maids and servant staff due to odd mishaps in the home. Over the years, as the mansion fell into different hands, it appeared as though there were financial dilemmas. Even today among the ruins, some feel an uncanny sense of something supernatural, or they feel uneasy. It's possible that before the original fishing lodge was built, this plot of land and the area harbored something so hellish that it has placed its evil mark on others over the years and continues to do so even to this day.

SHOULD I STAY OR SHOULD I GO?

R obert Lamont originally hoped for a blissful summer retreat home when he had Summerwind built. It was going to offer the peaceful retreat that he and his family desired so much. But perhaps by the end, this dream had become an escape from the pits of hell.

The Lamont family were no strangers to living in the lap of luxury. Mr. Lamont was highly educated and intelligent, as well as a successful businessman. His wife, Gertrude, was a high society lady who clearly had the world at her fingertips. The home they owned in Forest Lake, Illinois, was a mansion in itself, and it's fitting that their summer retreat home would be the same. Due to the fact that Summerwind (or "Lilac Hills," as Lamont liked to refer to it) was so large, they acquired a servant staff. At first, things in the new home seemed to be normal and peaceful. But fairly early on, the maids began to complain of odd noises or smells and would tell Mrs. Lamont that they felt as though the home was haunted. I can only assume that the Lamonts initially scoffed at the idea of their luxurious home being haunted or possessed by some supernatural force. But they soon would learn that their summertime heaven would become their personal hell. The question they soon faced was: do they bask in the retreat they spent so much time waiting to enjoy, or do they escape while they still can?

Some time ago, I found the book called *The Haunted Northwoods* by author Tom Hollatz. He had a long chapter regarding Summerwind Mansion, including some very interesting details that I had never read

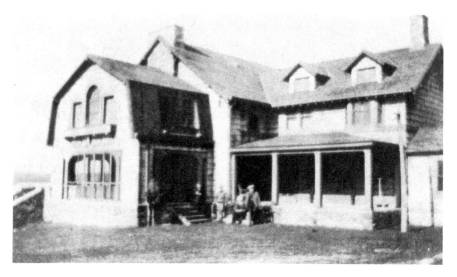

LaMonte Mansion West Bay Lake, Cisco Chain, circa 1925. *Courtesy of Adam Bauer.*

or heard about before. In regards to Robert Lamont and the property, he stated, "According to one story, Lamont designed Summerwind as an escape for himself and his wife, a haven of calm away from the roiling mish-mash of people and politics in New York, Washington, and Chicago. Together, they lovingly filled it with antiques purchased during the course of numerous trips abroad. The tales of the items that filled Summerwind are enough to set almost any collector salivating. Of great note was a pool table that graced the basement of the building. It held its place in state and was used with great regularity." Regarding this same pool table, Tom Hollatz mentioned it in his other book, *Campfire Ghost Stories*, stating, "'You should have seen the pool table,' one early Summerwind visitor told us. 'It was beautiful…it may have cost $25,000—back in 1929.'" The way author Tom Hollatz makes it sound, it was heaven at Summerwind. All the gorgeous antiques in each room of the mansion would have been an astounding sight to see. Unfortunately, according to Hollatz, all these precious antiques were taken by vandals throughout the years the home remained dormant. But the brightness of the sun, which streamed in through the many windows, was soon to be cast in darkness, reaching out to envelop and pull anyone into its dark despair.

I mentioned earlier that the maids and servant staff had gone to Lamont, telling him that they were encountering odd sounds and smells. They told him that they believed the home was haunted, but Lamont

and his wife continued to ignore the complaints, thinking that there was no way the home could be haunted, due to the fact that it was just built and still new. But after the events of one night, the Lamonts fled the home and never returned. Robert and his wife, Helen, came face to face with something truly terrifying. I found an online blog at travelcreepster. com, and the unknown author stated, "Following a late dinner he and his wife were enjoying dessert when the door to the basement pantry began to shake violently. Mrs. Lamont was so terrified that she took cover behind her husband, and then the door swung open and both witnessed what they described as a 'ghoul.' Lamont described the man as far too tall, dressed in black, and swaying as though made from smoke pushed by the breeze."

Mr. Lamont didn't think twice before grabbing his pistol, taking aim and firing two shots at the supernatural being, leaving two bullet holes stuck in the door. The entity then vanished. I always was curious as to how this particular story circulated and what its origins truly were. The unknown author of claimed, "He would later tell his long time hunting partners of what had occurred within the mansion that night." This is the first account I have come across that speaks of "he," meaning Mr. Lamont, telling certain people of what happened that night. Who knows what truly happened that day in the 1930s when the Lamonts reportedly faced the ultimate paranormal terror. If the family did encounter something from another realm, I'm not so sure the entity ever left. It isn't as though the family left because of the financial burden of having and maintaining the home. It was in the Lamont family for about fifteen years before the day they left and never returned.

The closest evidence there was regarding the bullet holes in the basement door were two photos taken by a man by the name of Todd Roll, who visited the Summerwind property back in the 1980s. He found the exact door and saw what appeared to be two bullet holes lodged in it. He then snapped a few photos, and these photos would go on to hold significant power in the alleged haunting of Summerwind. According to the book *Weird Hauntings: True Tales of Ghostly Places* by Joanne Austin, Todd Roll was interviewed and stated, "When I visited the mansion in 1987 as part of a small team of paranormal investigators, the door from the kitchen to the basement did indeed show two bullet holes. The door mysteriously disappeared some time between my first and second visits, and I've always wondered who took it and where it might be today." I have had the pleasure of speaking with Mr. Roll, and he has been

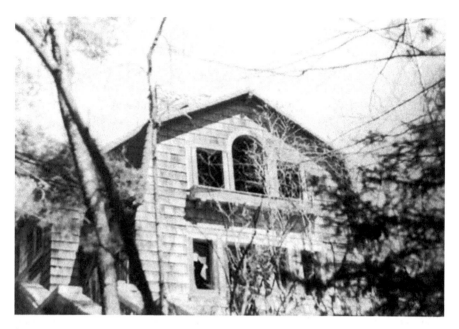

Summerwind Mansion, circa 1980s. *Courtesy of Todd Roll.*

fascinated by the property for years. He is a skeptic and is still questioning what many Summerwind enthusiasts ask, such as whether the encounter between Lamont and a ghost really happened. Did those bullet holes actually come from his gun? Or perhaps the bullet holes were made by an individual or individuals who had heard the legend and wanted to see it grow.

There is a strong possibility these holes were made from a different gun many years later. But why did the Lamont family leave? Did they truly leave that suddenly out of the blue? Why is there no more information regarding the Lamont family and the mansion? One would think that if Mr. Lamont sold the property, there would have been more information regarding the sale or why he sold it. They were a wealthy and public high society family, yet after they rid themselves of Summerwind, there was no further talk connecting the family to the home. To the best of my knowledge, no other articles were written mentioning when the family sold their summer retreat home or why. Whether the motive was because of the fear he and his wife faced in the kitchen that night or because one day they simply decided that they no longer wanted the home, it is all shrouded in mystery. I can't believe that the Lamont children

or grandchildren never spoke openly or publicly about the beloved Summerwind, in which Robert Lamont took so much pride. If you love a home that much, why vacate and leave it barren? It was almost as though something had to have occurred for Mr. and Mrs. Lamont to leave and never look back. This question will most likely never be answered, but we cannot account for what really happened or totally discount what happened either. So, like most paranormal stories, this has been shelved away and will continue to be remembered and talked about for many more years to come.

This begs the ultimate question: did the Lamont family end up fleeing in terror and escape a home they had originally built as a summer retreat? It is ironic that the home was meant for rest and relaxation—it was meant to invite you in, not drive you out.

LOVE IT OR LIST IT?

I have come across other articles that state Summerwind Mansion was sold after Robert Lamont's death. However, I have read that prior to Lamont's passing, he refused to return or sell the property. I wonder if Lamont had some strange connection to the home, or perhaps he was the first in a long line of individuals who would become trapped in Summerwind's magnetic hold. The house stood vacant up until his death in 1948, and then it was sold. According to an online article titled "The Haunting of Summerwind: A Frightening Haunting in Wisconsin," written by an author who went by the name of "Kitty," "The Lamonts sold Summerwind to the Keefers in the 1940s and the Keefers owned Summerwind until the 1960s." They were neither the first nor the last to face personal difficulties when coming into contact with the old mansion. According to a paper written on December 22, 2006, by CJ Bernier, "Even though they never truly stayed on the property, they faced much devastation. For instance, only after owning the mansion for six months, Mr. Keefer died of common causes. This meant that the property now belonged solely to Mrs. Keefer. She soon began to sell pieces of the property until all she had left was the bit of land that the mansion sat on. She ended up selling this numerous times, but the property was always reverted back to her because the owners faced financial trouble and despair."

I have also read, regarding Mr. Keefer, that within months after living in the mansion, he was found dead of a massive heart attack. There was no

reported paranormal activity of any kind at that time; however, that could either be because no one resided within the home to experience and report anything or because the home was never haunted to begin with.

In the 1960s, Mrs. Lillian Keefer did indeed sell the mansion several times, but as the authors mentioned in this chapter have both stated, each time she sold the home, the buyer(s) couldn't keep up with the payments, experiencing severe financial problems. As a result, Mrs. Keefer took back the property. According to the online article mentioned earlier by "Kitty," "Many people who toured the haunted home claimed that Mrs. Keefer would barely ever go inside with them, that she would just hand them the keys and expect them to fend for themselves…for lack of a better phrase." Some individuals who either toured the home as potential buyers or just as curious bystanders claimed that even though they saw nothing unusual, they did feel strange or uncomfortable while in the home itself. This went on, and after about five different buyers came into financial difficulty when purchasing the property, the Hinshaw family took one look, and Ginger fell in love with it. That was that. They were the next in line to own and reside inside Summerwind Mansion. Thus, the next chapter of this mansion began.

SKELETONS IN THE CLOSET

In the summer of 1969, Arnold and Ginger Hinshaw, along with their four children, moved into the mansion. Ginger had completely fallen in love with the house and couldn't wait to remodel the home and make it their perfect cozy getaway on the lake. She was recently remarried and, after moving for most of her life, had envisioned Summerwind to be the last home her family would ever need or want. Ginger thought the landscape was beautiful and peaceful; however, many locals cautioned her to be wary because she was moving into "the haunted house." She and her family forged ahead and decided to move in, ignoring the ominous warnings of others.

Ginger's husband, Arnold, owned a construction business and became excited when he first set eyes on the derelict mansion. He saw so much potential and couldn't wait to start renovations. Within one month, the family had moved in. Ginger repainted the entire living room, as well as all the woodwork and trim, and wanted to put her own personal touch on the house. But the task of renovating the majority of the home would prove difficult. When Arnold and Ginger asked local companies for estimates or even to come out and look at the home, contractors would ask for the address. After hearing of the home's location, they would want no part in fixing the home up. Some workers would leave supplies for them but would drop them off at the end of the driveway; they wouldn't even dare drive up to the house. Unfortunately, the Hinshaw family had to start the tedious process of renovating all on their own.

One day, while Ginger was going through a bedroom closet, she discovered the original blueprints for the mansion. Inside the roll of the blueprints lay a peace pipe. Ginger was immediately both confused and fascinated and almost became obsessed with turning the house back to its original state. She was adamant on making sure that everything matched, even the original colors of paint on the walls. She felt as though someone or something was sort of guiding her, telling her what to do with each portion of the home. One of the Hinshaw children, "Mary," who was nine years old at the time, had an uneasy feeling about the mansion, even from the very beginning before moving in. It could have been because the home was in such a state of disrepair that little Mary was disgusted by the dust, cobwebs and bats that had taken over the residence. Or perhaps the little girl felt the restless evil and could not or would not be enticed by the house as so many others had before.

During the time of the renovations, Arnold started to become very much on edge. He would snap at the children for no reason, stay up into

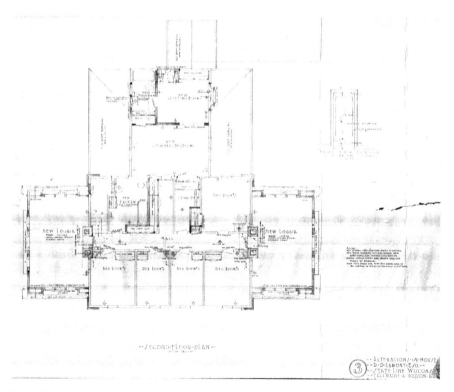

Second floor of main house blueprints for Summerwind Mansion, circa 1916. *Courtesy of Joshua Chaires.*

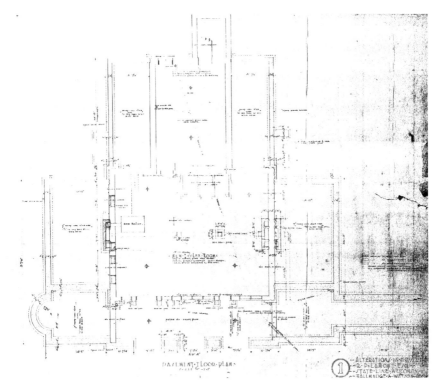

Basement floor plan of main house blueprints for Summerwind Mansion, circa 1916. *Courtesy of Joshua Chaires.*

the wee hours and play the organ that was on the first floor. He would yell at the kids for pushing certain windows open, even though Ginger remembered closing those windows herself earlier. One window in particular proved to be an issue, and eventually Arnold nailed the window shut for good. She then started to wonder if Arnold was lying about the windows or other odd occurrences happening in the home. They would see odd flickering of lights and see shadows out of the corner of their eyes, and Arnold even felt a presence while walking down certain halls of the home. On one occasion, Ginger felt a presence and turned around but saw nothing. They also heard soft whispers within the shadows and behind the doors of empty rooms, but when they walked in to see if anyone was there, they were met with nothing at all. This happened multiple times to both. I have read several times about a mysterious woman who would walk back and forth in front of the French doors that led to the dining room. Several witnesses, including the Hinshaw family,

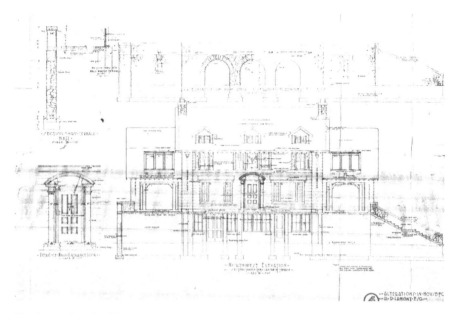

Northwest elevation blueprints of Summerwind Mansion, circa 1916. *Courtesy of Joshua Chaires.*

spoke of this mysterious woman, and they always stated that she didn't appear as a ghost; she looked like a real person, and some asked who the unknown guest was. As if that wasn't enough, appliances would start up or shut off on their own and the hot water heater and water pump would break down, but when the service company would come out to fix it, it was oddly not broken, as if it fixed itself. One day, Arnold was just exiting the house and walking to his car when the car suddenly burst into flames! Thankfully no one was near the automobile, and they never figured out why it caught fire. Even though by this time the family was uneasy, they continued to try to make the best of the situation and to look ahead to making Summerwind their dream home.

On a cheerful summer day, Ginger and Arnold started painting a closet in one of the bedrooms. A large shoe drawer had been built to fit in the closet's back wall; Arnold pulled it out so he could paint around the frame and edges but first noticed that there was a large space situated behind the drawer. With flashlight in hand, he was able to work his way into the tight space, but after shining his flashlight in the darkness, he jumped and crawled out of the space quickly. He told Ginger that there was a corpse inside! They assumed that it was probably a dead animal that had gotten stuck back in the small space, so when the kids came

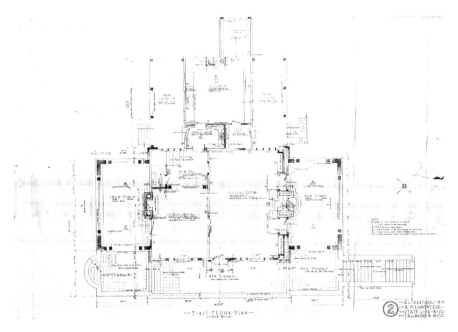

First-floor plan blueprints of Summerwind Mansion, circa 1916. *Courtesy of Joshua Chaires.*

home from school later that day, Arnold asked their daughter Mary to crawl inside with the flashlight to get a better look. Since she was smaller, it was easier for her to work her way into the crawlspace, and after getting inside, they heard a bloodcurdling scream. She came out immediately and claimed that she had seen a human corpse and also that she saw a human skull that still had some dark hair attached to it, as well as an arm and portion of a leg. This grisly find would always be one of the main legends that came with the old home. For some reason, the Hinshaws never reported this macabre find to the local police. Is it possible that perhaps this story was made up later on just to add to ghost lore? This is just another mystery that surrounds the old ruins to this day. We can only assume that if there really was a body in that crawlspace, the Hinshaw family left it alone. But what if this body was the reason for the paranormal events that took place within the home? If the family either had reported it to local law enforcement or laid the body to rest with a proper burial, perhaps this would have stopped any supernatural activity at the home dead in its tracks. It wasn't until after this disturbing event that life at Summerwind for the Hinshaw family started to go terribly wrong.

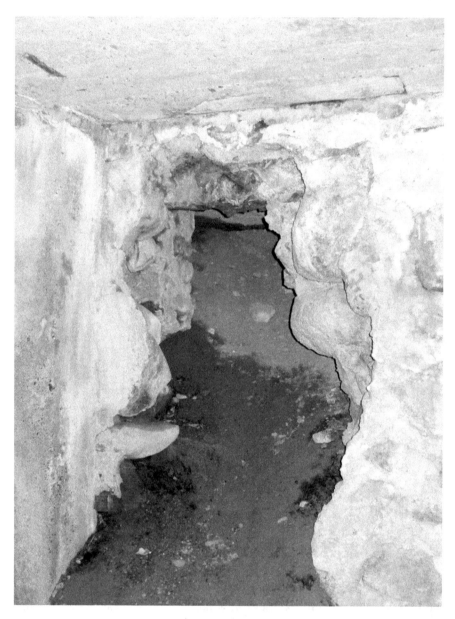

Ruins underneath terrace at Summerwind, 2010.

Arnold started to suffer from insomnia and would stay up all night, playing the organ that he had purchased before moving into the mansion. Previously, he would play from time to time because he loved to play; it was a healthy hobby. But his playing became much more than that. The

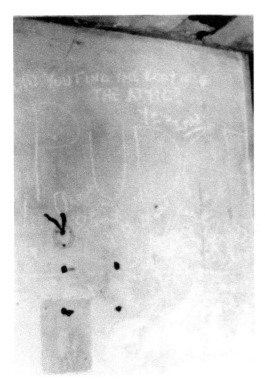

Writing on either a door or wall that reads, "Did you find the body in the attic?" circa 1980s. *Courtesy of "OMW."*

songs he would play became very dark, and he would mix certain tunes together that would sound completely mismatched and off-pitch. He would play louder and louder, with more of a turbulent and frantic sound. Many nights his playing would become so loud that Ginger would run down the steps and beg him to stop playing. The children and Ginger simply could not sleep with the bellowing organ music below them. Arnold's defense would be that the demons in his head made him play continuously. Eventually, poor Arnold had a complete mental breakdown, and simultaneously Ginger also attempted suicide because she could no longer bear seeing the man she loved slipping away little by little. The children were afraid of Arnold, and he lashed out at them, even killing a pet they loved so much. As a result, Arnold was sent away to obtain treatment. Ginger and the children moved out of the home and traveled to Granton, Wisconsin, to live with her parents. Eventually, Arnold and Ginger divorced. Ginger's health became better after moving out of the mansion, and she went on to marry a man by the name of George Olsen.

Was Arnold's breakdown due to some genetic or predisposed mental illness that he carried with him for years? Or was it Summerwind Mansion, wreaking its havoc and unraveling this once happy family? It is no mystery that this house had affected prior families, but I often wonder if the case of Summerwind Mansion was similar to the famous Amityville House. In the late '70s, a family moved into this big beautiful home in Amityville, New York. Within weeks, they experienced supernatural terror and eventually fled, never to return. Later on, these terrifying events were published in a popular

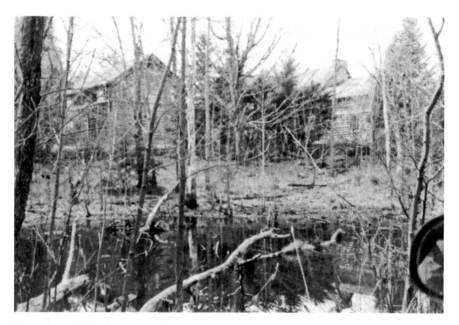

Summerwind Mansion from a distance, circa 1980s. *Courtesy of "OMW."*

book and that led to Hollywood making the classic horror film *The Amityville Horror*, which millions have seen over the years. The family who lived in the Amityville house at 112 Ocean Avenue was reported to have gotten in over their heads when purchasing the home. They ran into financial difficulties and could not keep up with the mortgage. Did the Hinshaw family face the same issues with Summerwind Mansion? Or did supernatural events truly happen in Amityville and at the old Lamont Mansion? Again, everyone has their own opinion on these cases, and this is why they are so popular. They cannot be proven, and both remain unsolvable mysteries.

SYMPATHY FOR THE DEVIL

I fell in love with the house immediately. Had to have it. Absolutely wanted that house in the worst way. Felt sorry for the house. Really, really sorry.
—Ginger Hinshaw

Make no mistake: Summerwind Mansion definitely has a hold over some people. After the Hinshaw family fled the home as a result of all the terrifying activity, Ginger assumed that she was leaving the menacing mansion behind her. But she was wrong. Some time later, her father, Raymond Bober, announced that he was going to buy the property, fix it up and turn it into a bed-and-breakfast. Ray obviously felt empathy for the home: "Summerwind looked like it needed somebody. It's like seeing a wet puppy; you want to comfort it. And that house almost reached out to you and asked for comfort." Ginger was absolutely horrified and pleaded with him not to step foot on the property; however, he would not listen. When Ginger was interviewed for *A Haunting*, she stated something that had me both chuckling and shuddering: "By that time, I was a little tongue in cheek—ah yeah ghosts, right on. He said it's okay; Ray needed a project. They got a project all right, they got a real project."

Ray and his son lived on site in a camper parked in the driveway while they started working on the home. At this point, the old house was in shambles and in dire need of general cleanup. They started right away, eager to get the B&B going sooner than later. But those were not part of Summerwind's plans, and when it was all said and done, father and

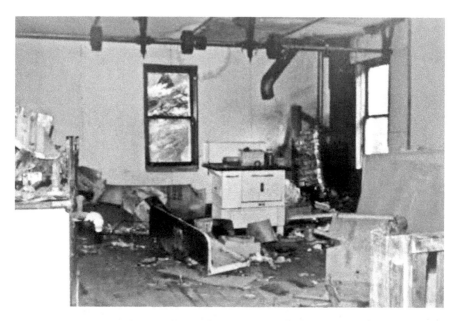

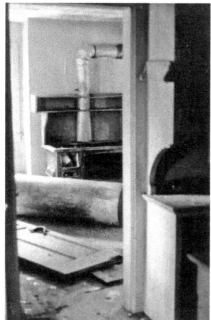

This page: Interior of Summerwind, circa 1980s. *Courtesy of "OMW."*

son were running from the home just as the Lamont family had done so many years ago.

According to a young lady named CJ Bernier, who wrote a research paper in 2006 called "Eternity in the Northwoods," "[Raymond Bober] hired some men to help him fix the place up, but everyone had an excuse of why they couldn't help. Some said they were sick while others flat out said the place was haunted and they didn't want any part on it. Raymond would measure rooms to see how many people he could seat in the dining room, but everyday the measurements were different. He even compared them to the original blueprint and found that some days the room was twice as big as it was supposed to be." Apart from the odd sizing of some rooms, Ray's son, Raymond, had a chilling experience of his own that would stay with him for years. Ms. Bernier spoke in her paper of Raymond's experience with a certain window during a rainstorm:

> *Since the rain was pouring in, he quickly shut it and went to get a mop. When he was finished cleaning up the water in the bedroom, he began to mop the hallway which seemed to get longer and longer as he went. Once he reached the end of the hallway, he looked into the doorway of the master*

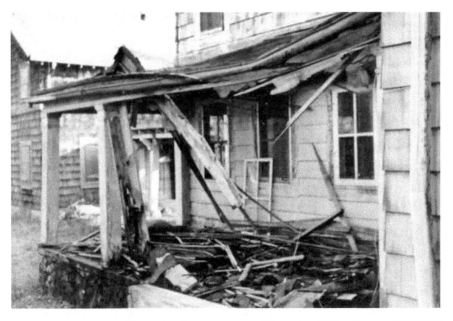

Exterior of part of the old mansion, in very poor condition, circa 1980s. *Courtesy of "OMW."*

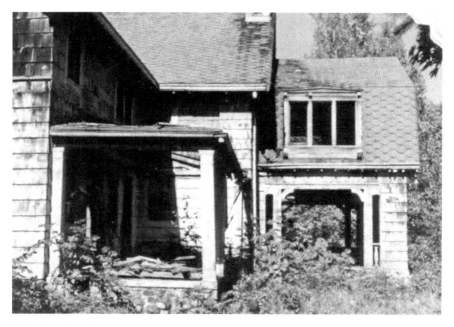

Side of porch at Summerwind Mansion, circa 1980s. *Courtesy of "OMW."*

bedroom to find the window open again. He shut it and started mopping again when he heard someone say his name. He asked who was there. When no one answered, he figured he must have been hearing things. All of a sudden, he heard it again more clearly. He was headed downstairs when he heard two gun shots. He raced around the house and reached the kitchen to find smoke and the smell of gun powder.

In a stunned state of shock, Raymond raced outside to see if someone had been in the home and fired a gun, but he found absolutely no one and didn't hear anyone running away or speeding off in a car. He went back inside and cautiously entered the kitchen again. Whatever happened after that, Raymond refused to speak of it no matter the questions he was asked. Someone or something had scared him into silence.

Shortly after, Ginger visited her father, who started to go into detail about all his plans for converting the old mansion into a hotel and restaurant. As they were sitting over some blueprints that Ray had drawn up, Raymond started to become anxious and fidgety for unknown reasons. Ginger noticed that he was biting his nails and asked him what was wrong. When he tried brushing it off, she exclaimed that she had

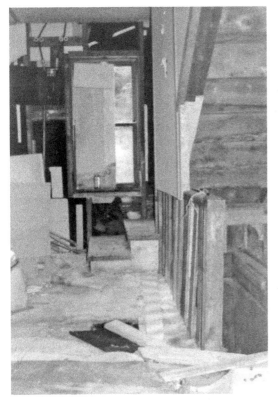

Left: Inside part of Summerwind Mansion, circa 1980s. *Courtesy of "OMW."*

Below: Another photo of the interior of the mansion, circa 1980s. *Courtesy of "OMW."*

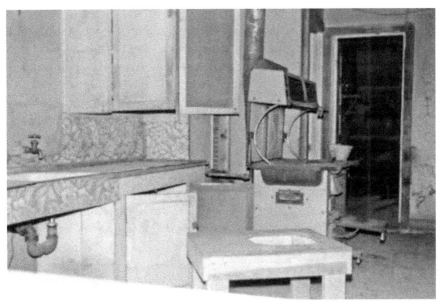

recently been studying hypnosis and that perhaps using this on him might help him with his nervous nail biting. Raymond agreed and sat next to her, getting as comfortable as possible. Ginger held up a pen in front of his face and told him to concentrate on the object. He started to become drowsy and eventually fell into a half-sleep state. Ginger's daughter, Mary, was standing outside the door to the room they were in and recalled her mother asking her uncle general questions and then questions about Summerwind. Immediately, Raymond's leg began to bounce up and down and shake uncontrollably.

Mary was a child when this occurred, and she remembered thinking that her uncle appeared at first afraid, but as the hypnosis session continued, his voice started to change and became deeper, almost a growl. He stated, "I am strong. I am strong. You are weak." His face contorted in anger as he kept repeating this over and over again. Ginger asked, "Ray, where are you?" He kept repeating, "I am strong, you are weak." Ginger grabbed a cross and started attempting to diminish the evil presence that had taken over her brother's body. After the presence seemed to leave and Raymond became still, opening his eyes and asking what had happened, Ginger was in shock that he recalled nothing. Even though he had just witnessed such a terrifying, unexplained scene, their father, Ray, remained skeptical and thought that it was their overactive imaginations taking over. Luckily, Ginger had tape-recorded the session, and when they played it back, Ray was in awe and terror of what he heard himself say on the recording. It was an angry voice stating that he was very old and strong, that others were weak, that he despised his children—he had seven children, and they were *all* weak and he was very strong.

This prompted Ray to finally divulge his horrific encounter at the mansion while he was alone. According to the book *The Carver Effect*, which was published in the late 1970s:

> *"I wonder how the box finally ended up in Robert Patterson's possession?* *You know,"* remarked George thoughtfully, *"this could give historians a* *lot to think about!" "I think it gives us more trouble than historians!"* *I responded. "After two hundred years, Carver probably has no direct* *living heirs surviving, what could they possibly lay claim to? The land* *has long since been ravaged and those responsible are dead and gone* *with their estates divided or destroyed." Karl was likewise thoughtful.* *"Carver evidently wants the legal title to the land established. After all,*

*that's what Robert Patterson was supposed to do!" "You have a point,"
I admitted, "Carver hated weakness in any form, and I'm sure he didn't
want any loose ends dangling around." "He might also want a little
recognition for what he did accomplish," Ginger offered. "Not that I
blame him. He took terrible risks and did a magnificent job." "But what
are we going to do now?" Mary asked. "Do?" I echoed impatiently.
"We're going to find that damned box!"*

After Raymond had run downstairs, hearing gunshots, he had made
his way into the kitchen. When he had looked around and calmed down
a bit, realizing that no one was there, he walked over to the door to the
basement. He saw a few markings on it, and as he ran his fingertips over
the old bullet holes that were made so many years ago, supposedly by
Lamont encountering a spirit, a presence crept up behind him and came
right at him. But before it could harm him, Ray ran as quickly as he could
to his vehicle and sped away. After his father, Ray, heard the story, he was
convinced that there was a connection between his son's experience and
what happened to the Lamonts back in the 1930s. He thought that there
was a powerful force that was trying to communicate with anyone who
stepped inside the mansion. He then asked Ginger to hypnotize him to
see if he could get any more answers. After she had him in the hypnotized
state, he saw himself back at Summerwind, walking into the basement. He
went directly to a part of the basement, taking a tool and removing a piece
of the foundation to expose a wooden box. He opened the box, and at this
point, Ginger asked him to write down what was inside it. Ray took pen
and paper in hand, and Ginger noticed that he looked as though he was
dipping the pen in ink and shaking it. Then he started writing as though
he were using quill pen and parchment paper. All he wrote on the piece of
paper was a name: Jonathan Carver.

With this name in hand, Ray Bober visited the local library and started
researching Jonathan Carver. Carver was born in 1710 in Massachusetts
and later moved with his family to Connecticut. He married Abigail
Robbins and became a shoemaker, and reports have stated that the
couple had seven children. In 1755, he joined the Massachusetts colonial
militia at the start of the French and Indian War. Then, in 1757, Carver
enlisted in Burke's Rangers, which became a part of Rogers' Rangers
a year later. During his time in the war, he studied surveying and
mapping techniques and became so highly ranked that he was promoted
to captain of a Massachusetts regiment in 1761. However, he left the

army two years later, wanting to focus his time and energy into exploring new territories the British had acquired as a result of the ongoing war. Eventually, Carver made his way into Minnesota and also Wisconsin. Jonathan Carver is noted quite a bit in history as being a great explorer, and many areas were named after him in later years. In 1766, he was exploring parts of Wisconsin, and many historians have learned through his numerous journals that he made a deed with the Sioux tribe.

Author Tom Hollatz digs deeper into Carver and this infamous deed in his book *The Haunted Northwoods*, stating that Carver's journals were published in a book called *The Journals of Jonathan Carver and Related Documents, 1766–1770*, reprinted by the Minnesota Historical Society. It contained information and papers that were written by the explorer; however, the deed that's claimed to have been buried in the foundation of Summerwind was not included in the book. However, when the second edition of this book was released, the deed was included, supposedly after the death of Carver's wife, who had had it in her possession all along. Hollatz stated, "The deed's very existence is in question. There were several editions of 'The Journals of Jonathan Carver and Related Documents, 1766–1770' published. Because Dr. Lettsom added the text of the deed for his second and subsequent editions, questions have proliferated regarding the validity of the deed itself. That, in and of itself, is enough for historians to doubt the existence of the deed. Some have gone so far as to call it 'fraudulent.'"

This deed was reported to have been drafted up and signed on May 1, 1767. Hollatz went on to state, "A council was held in a great cave, now known as Carver's Cave, under the bluffs of the Mississippi River near St. Paul, Minnesota. This council, according to 'The Journals,' drafted a document that gave much of present-day Wisconsin and part of eastern Minnesota to Jonathan Carver 'in return for the many presents, and further good services.'" There was a parcel given to Carver that was "a tract of land that stretched from the Falls of St. Anthony along the east side of the Mississippi River south to the mouth of the Chippewa River, then due east for 100 miles, due north for 120 miles, and back in a straight line to the Falls of St. Anthony." This deed was signed by Hawnopawjatin and Otohtongoomlisheaw, two Sioux chiefs whom Jonathan Carver had known. A Dr. Lettsom reportedly handed the deed over to Carver's widow, who was living in London, England, at that time. After she passed away, he tried in vain to find this deed and in 1804 believed that it no longer existed. Even though this mysterious deed was

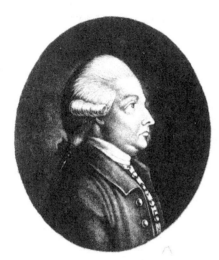

Capt. JONATHAN CARVER.
From the Original Picture in the Possession of J. C. Lettsom M.D.

Portrait of Jonathan Carver. *Courtesy of Wikimedia Commons.*

mentioned in the journals book, Carver did not speak of it in any of his recorded travels. He mentioned the cave and spoke in detail about the beautiful scenery, but that was about it. The explorer was known to be very meticulous in all his entries, not leaving out any minute event or detail; to some historians, then, if the deed was real, why did Jonathan Carver not ever mention it in any of his writings?

Carver ran into hard times when he returned to London after his expedition. He wanted to publish his book, especially because it had received much notoriety; however, he passed away in 1780, completely penniless, before he could reap the financial benefits from the publication. Thereafter, he was buried like a pauper in a potter's field located in London. It was such a bittersweet ending to a man who seemed to seek out so much in his lifetime. Since the infamous deed had surfaced in rumors only, many have attempted to find it and try claiming it for themselves, but to no avail. Perhaps this is one of the alleged curses of Summerwind? Many years ago, someone asked a gentleman by the name of Will Pooley about this deed, as he actually had helped pour the foundation of Summerwind Mansion when it was being built. He stated that he remembered nothing being put into the concrete or foundation and had no memories of anything odd occurring. Several other workers who had worked with Pooley also denied any strange events, so this has definitely made some skeptics' ears perk up, now questioning even further if the terrorizing tales of Summerwind are all false.

But Raymond Bober disputed these claims and truly believed that the home was haunted by the ghost of Jonathan Carver. After Ginger had performed hypnosis and he had made what he claimed "contact" with the angry ghost of the British explorer, he became even hungrier

for further knowledge regarding Carver. According to a University of Wisconsin–Eau Claire student named Sara Falch, who wrote a history paper in 2008 on Carver titled, "Jonathan Carver's Footprints: The Carver Land Grant Case of 1825 and the Impact of American Indian Policy," she practically opened up her paper talking about Summerwind and the connection to Carver:

> *Bober claimed through dreams, trances, Ouija board and automatic writings, he was able to communicate with Carver and that the ghost of Carver requested his help. Carver told the Bober family to find the box in the base of the house. The family searched for but did not find Carver's "black box." However, Ray Bober could not let go and continued to make "contact" with Carver's spirit. As a result of this communication and experiences with the Summerwind home, he wrote and published the book, "The Carver Effect" in 1979 under the pen name, "Wolffgang Von Bober."*

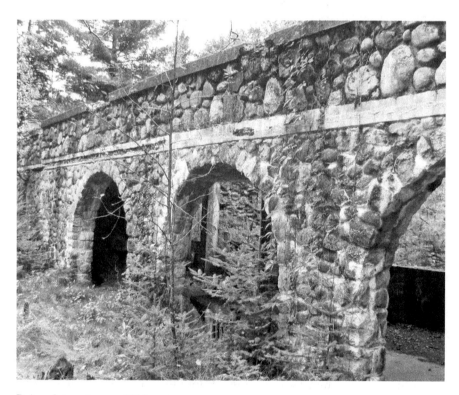

Ruins of stone terrace, 2010.

Post Office Box 142
Granton, Wisconsin
54436

January 11, 1982

Dear Ms. _

Sorry for the delay in answering your letter.
Please understand that there is a lot of correspondance
involved when one writes a book and it does take a bit
of time to get around to all the letters.

I do want to say 'thank you' for your interest in
The Carver Effect and I am sure that you will be interested
to know that there will be a sequel to it in the near future.

Summerwind was sold approximately two years ago. The
'why' should have been obvious. I just could not afford the
financial responsibility that Summerwind invoked. Even though
the new owner was warned of the drain that this property
placed on the owner the purchase went through. Now I under-
stand that this individual is also suffering some of the same
symptoms that tortured my pocketbook and my psyche.

As to why there are no records. There are, you just did
not locate them....I do have prints of Summerwind and if the
publisher agrees they will appear in the next book, and you
will be able to enjoy them.

You are quite correct in assuming that 'Windfall' is
the name that I used for my home town of Granton. Summerwind
was the name that I found buried by the road that enters
the property. Whether it had ever been used is a matter of
conjecture? Perhaps it had, in any event, I liked it.

Just a bit of advice. If indeed you ever manage to
get on the property there in the Northwoods. Use a bit of
caution, be careful of your health and your values. The book
was not wrong in suggesting that strange things did happen
to people no matter what their disposition!

Yours truly,

Wolffgang Von Bober

Letter from "Wolffgang Von Bober" to fan/Summerwind enthusiast, circa 1982. *Courtesy of "OMW."*

Whatever the case is with this book, it was written, in my opinion, very well. Bober captured the mood and feel of the first time he ventured to the old mansion:

> *I stood there for a moment and surveyed the place. The house was austere—yet pathetic. The woods, the beach, the playhouse built especially for children—all the things that make life enjoyable—were there. Yet, during the past thirty years, the rooms that now were so dismally vacant and grimy should have been filled with the joyous sounds of laughter and comradeship and scampering of childish feet on the stairs. I let my imagination drift idly for a moment. The house reminded me of a frustrated old maid who had let life pass her by while she waited for a special Mr. Right to come along. Was I the right owner for this house? Had certain secret forces, openly acknowledged by Ginger and vaguely hinted at by Mrs. Murray, accepted me? Or had they, figuratively speaking, girded up their loins—and now were waiting for me?*

Bober also mentioned a notion of the old home having a "draw" or "pull" to it, as I have mentioned, but I find his take on it very fascinating: "Surprisingly, Summerwind Mansion held little appeal for most women, although there were a few exceptions such as Ginger, for instance. However,

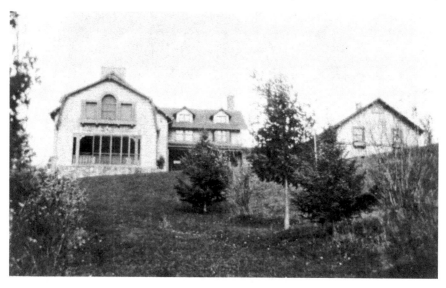

LaMonte Mansion West Bay Lake, Cisco Chain, circa 1925. *Courtesy of Adam Bauer.*

all the men found it almost irresistible. It was as if the place were some sort of siren who used her wiles and charms mainly on the male sex. The desire to own the building seemed to be a common factor in them all."

It's an interesting comparison between a siren and the home, and this is not the first time I have read about certain locations, with rumors of hauntings being compared to that of a creature such as a siren that calls out to people and has this hold over individuals, even commanding they do their bidding no matter the cost. Deed or no deed, these grounds seem to be holding something among the overgrown grass and weeds. The question, then, is simple: what is this something?

Perhaps this deed is not buried in the old foundation of the ruins of Summerwind, but that doesn't mean that something else isn't buried there beneath the broken bricks and crumbling foundation—something that is watching and waiting to strike out at another individual the way some have claimed it has done over and over again. If the ruins aren't haunted by Jonathan Carver, seeking revenge because he wants his deed back, is it possible that the reports of a "woman in white" are true? The old mansion might be harboring a female, not a male, spirit.

You're My Obsession

There are countless locations or even possessed/cursed items that I have read about or seen on TV that are reported to have a powerful, magnetic hold over people. Summerwind definitely seems to fit this description. Many who have flocked to it over the years, even before it burned to the ground, visited because of this "pull." They felt as if they needed or had to go there. When coming across these many stories, it never ceases to amaze me—the power that a location like Summerwind has. If anything, the yearn or pull is even greater now due to the condition of the house in ruins. Some say that it's sympathy, and I tend to agree with that. That is exactly how I felt when I visited a few years ago. I felt hollow and empty, just a vacant loneliness while there. When I stepped up and stood on the crumbling back terrace, it was haunting, yes, but waves of sadness also swept over me. It's not difficult for people to feel sorry for what used to be; I think it's within our DNA as humans. But I also wonder if this is a trick—that perhaps this sympathy is meant to lure visitors in to entrap them in some hellish obsession.

When reading Tom Hollatz's *Campfire Ghost Stories*, I came across two stories of this nature. The first was a response Mr. Hollatz had received after writing an article on the old mansion. An individual called him up and told him that he was very affected by Hollatz's article, stating, "I should mention that I'm an artist and have never been moved by anything. It was haunting. There was a presence." At first, Hollatz was chuckling under his breath, until the artist went on to say, "I burned all of my paintings. All of my oils, I set a match to them. They're now ashes." When asked why

the artist would do such a thing, he replied, "There must have been a 100 or so. But nothing has possessed me as Summerwind. I must, I must get there and paint that structure. You must tell me how to get there, please." Hollatz never liked to disclose the exact location due to vandalism and kept to his word on this. He gave the artist a nudge in the right direction and wished him luck. The man's voice was hoarse as he kept repeating, "I need to paint that place, I must paint that place."

Hollatz also wrote about a letter he received from a man in Ireland who had seen the *LIFE* magazine spread on the old mansion and read Hollatz's article plus looked at the pictures the author had provided. The Irishman claimed that it "did" something to him:

> *I slowly started thinking about Summerwind. It started to haunt my every thought. Now this is strange, isn't it? And then strange things did begin to happen to me. My girlfriend was killed in a car I was driving. It was my fault totally. I was drunk out of my mind. A lawsuit resulted from her family, crippling me financially. Later that winter, I slipped on the ice and broke my leg. My home was then burglarized. The reason I am writing you is to tell you what Summerwind did to me. I'll never be the same again. Why did you write that piece? Why? Why? Why?*

I have talked about my friend who ended up with a piece of a brick from the original mansion foundation and had bad luck and tragedy strike him as well. Some have dubbed this the "Curse of Summerwind Mansion," and perhaps this should not be taken lightly. Ginger and her father, Raymond Bober, felt that "pull," and at one point in their lives, the place had a hold on them. Whatever may be present at this particular location seems to have a strong energy and could be a force to be reckoned with. Take this with a grain of salt, but I've noticed a theme with these obsessions or fascinations with the house: mostly men are the ones who fall victim. I'm not saying no women have been drawn to it; obviously Ginger Hinshaw was taken by the house, wanting to bring it back to its original glory. However, I'm seeing many men who were affected by this "curse" and fell victim. Arnold Hinshaw became obsessed with playing the organ that was on the main floor and had claimed that the ghosts in the home made him do it. If this has any truth to it, I wonder why. Could it be Lucy of Lilac Hills, still angered by her husband and seeking revenge on the opposite sex? Maybe there is some truth to this quote from William Congreve: "Heaven has no rage like love to hatred turned, Nor hell a fury like a woman scorned."

DARK TALES OF LILAC HILLS

In one aspect, yes, I believe in ghosts, but we create them. We haunt ourselves.
—Laurie Halse Anderson, Wintergirls

When I came across this quote, I overanalyzed, as I usually do. At first, I thought that it was a clever saying and quite deep actually. It makes sense that we as humans can create them, whether it's in our heads or literally conjuring them up. But then I started pondering the actual concept of us haunting ourselves because of this. It's a very interesting, almost psychological take on the paranormal, which in my opinion works hand in hand many times. So, is it possible that the only way ghosts are created is from the living? Do we breathe life into them in the literal sense? With loved ones we have lost, we keep their memories alive, but how far does that go? After reading this simple quote, I was more inquisitive than ever before. I guess it just depends on each person's opinion and how they interpret this quote. For me, the whole idea of ghosts truly being real, as well as the chance that they are created by people who are still alive, is truly unnerving. What's even scarier is that if we are haunted, we do not have anyone else to blame but ourselves.

After reading a chapter in Tom Hollatz's 2000 book *The Haunted Northwoods*, I was even more intrigued and mystified by the aura and legends of Summerwind Mansion. This was a part of the legend I was not familiar with and needed to know more about. It was the story of a "Miss Lucy of Lilac Hills." Once I saw her name appear, she and her tragic story

completely absorbed me. I thought of the quote by Laurie Halse Anderson and shuddered just a bit when it occurred to me that if I thought too long and hard about the story of the ghost Lucy, perhaps my own mind may actually conjure her up.

According to *The Haunted Northwoods*, "Another theory has surfaced over time; this one, I think personally, has a stronger chance of being true. It is a theory brought to light by a woman out of Cleveland, Ohio, named Emily Forsythe Warren. She spent her childhood on West Bay Lake, the same lake that Summerwind inhabits. Her tale is one of treachery and sadness and rings true when forced through the sieve of history." This statement was made after Tom Hollatz went into detail about the 1979 book *The Carver Effect* and other stories that had surfaced about the reported paranormal happenings at the old mansion. The tragic story of "Lucy" obviously grabbed his attention, and now it had grabbed mine as well.

The story starts out in the Deep South, shortly after the Civil War is over and Reconstruction has begun. During this time, transients from the North (called "carpetbaggers") moved through the Southern states looking for food, work and shelter. These men were driven by hopes of economic gain and a desire to work on behalf of the newly emancipated slaves, or a combination of both. They were viewed as opportunists, looking to both exploit and profit from the South's misfortunes (Southerners supporting Reconstruction and the Republican Party were known as "scalawags"). Times were tough, and the Southern plantation families who once had so much power and wealth were reduced to wearing rags and working the land with their own fair hands, when once the families' slaves labored for them. The daughters of the plantation owners were usually not viewed or taken seriously, as pampered and spoiled as many of them were. They weren't raised to speak their minds, as they were brought into the world with a silver spoon in their mouths. Incredibly, though, many of these girls were less valuable than the male slaves of the time. Some of these girls were even locked up inside their mansion doors, as if a prisoner in all the finery and riches they could dream. However, freedom was not a possibility. Some of these women were sent off to become mistresses to various powerful men, and some were actually sold into marriage to men a great deal older than them and total strangers—the marriage was more of a business deal and was oftentimes a loveless union.

Whitehall Plantation, situated just outside Atlanta, Georgia, was nearly destroyed by the carpetbaggers, and the lack of funds to restore the home left the Devereau family, who were the owners of the plantation,

in desperate times. There were three daughters who resided there who became ripe for the picking. This once powerful home and family had fallen on extremely difficult times, and with no marketable skills to fall back on, they were forced to sacrifice their own to forge ahead. One of the daughters, Lucy, was willing to try to save her family and became the mistress to a very powerful New York banker by the name of Lamont. She agreed to marry Lamont's son, Robert, and in return, Lamont bought Whitehall Plantation. Thereafter, Robert Patterson Lamont and his wife, Lucy, were able to live for a period of time at her childhood home. This poor girl made the ultimate sacrifice—her virtue and honor—to save her family. Even though she married the son of her former lover and did not love him, she moved to New York to live with her new husband, who was a stranger to her. Author Tom Hollatz stated, "Her black servant from home, Hannah, moved with her. Lucy learned to become a part of New York society and very quickly took up the harp, as well as learning to speak several different languages. She found enough to amuse herself and was relatively content in New York. However, Robert soon wanted to move. Lamont built a magnificent mansion on the shores of West Bay Lake in Wisconsin in 1916. He called the place Lilac Hills and moved his wife, who was pregnant, and Hannah to it. He promised Lucy a great life in the 'West.'" Robert and Lucy's first child was born at Lilac Hills. She gave birth to a son, and they named him James. At first, life seemed to be treating Lucy very well—she had a lovely home, a husband who offered her the many luxuries she had as a child in the South and a healthy baby boy on whom she doted. Unfortunately, young Lucy's happiness was as fleeting as the lilacs that bloom every year.

At first, Robert started telling Lucy that she couldn't go out for the day to go visit family and nearby friends. She was a virtual prisoner at the mansion, much like her childhood and adulthood were at her family's Whitehall Plantation. She must have felt very stifled and panicked, realizing that her husband was now driving people away from the home when they would come to call on his wife. To make matters worse, she soon found herself pregnant again. She gave birth to a baby girl and named her Lucy. Tragedy struck a short time later, when it was said that baby Lucy died during infancy. She is said to have been buried on the Lilac Hills property, and there was a small wooden marker within some trees that bears her name. After the sadness of losing her little girl, the only happiness and communication Lucy had was in sending letters through the mail to her family back in Georgia. In some of the letters,

she stated that strange things were happening at the mansion. She spoke of screams in the night, disembodied voices whispering "please come and see me" and her son, James, acting strangely, along with servants running to her with bruises and marks all over their bodies. The one room that was the most terrifying was the wine cellar, which was located in the basement. The entrance was reported to have been bricked over, but there were shackles attached to the walls. It was literally a prison, and at this point, Lucy was so scared that she was tempted to run away from her home and tormentor.

In *The Haunted Northwoods*, Hollatz stated, "Her husband hired an overseer to help control the lands, a man named John Whittington. Whittington befriended Lucy, and on one cold November day the four of them—Lucy, Whittington, James, and Hannah—fled over the railroad tracks to the near-by town of Ontonogon." Although freedom was just a breath away, it didn't last long. Lucy's husband, Robert, launched a full search, and the group was found later in Virginia. The group was trying to make its way back to Georgia to seek refuge with Lucy's family. Lucy was dragged back to Wisconsin, and from then on, nothing more was heard from her again. It was as if she dipped off the face of the earth. But some years later, she was seen. People reported that she was the shell of her once beautiful self. She was horribly thin and wan. It was as if her sheltered prison of a life had taken its inevitable toll and she finally gave in to it. The Lamonts' son, James, had been sent off to boarding school in New York and was reported to be very troubled and hard to manage. Had Summerwind ensnared this young lad at such a young age? Perhaps some ghosts do not discriminate when it comes to the age of the living. Many years later, the lady recounting this story, Emily, stated that she had last seen James pumping gas at a small filling station in Wisconsin. She noted that his clothes were tattered, but she knew it was him. When she asked about his mother, Lucy, and Summerwind Mansion, his face became ghostly white and he warned Emily to never visit Summerwind again.

Emily spent much of her childhood in the West Bay Lake area and had many friends with whom she ran around and played. They would run through the woods and explore down by the lake, just being kids and having fun. The only location that was prohibited by their parents was the Summerwind property. Now, this could have been because the mansion was in rough condition, and with small children roaming inside and outside, any concerned parent would obviously not want their child at

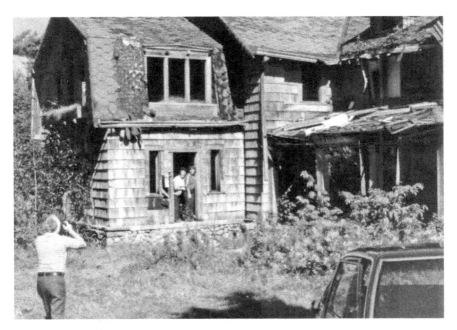

Outside of Summerwind Mansion, circa 1980s. *Courtesy of "OMW."*

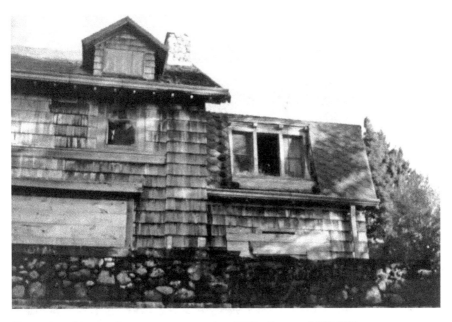

Upper shot of home, above stone terrace, circa 1980s. *Courtesy of "OMW."*

risk of falling or breaking a bone. The other reason the parents didn't want them going there may have been because of the supernatural reputation the place harbored. Like many other accounts of the paranormal, this is cause for speculation.

One summer day, the group of childhood friends took a boat out onto the lake, as they did many times. But this day, a violent thunderstorm came upon them quite suddenly, and they were forced to dock the boat and run up to the old mansion for shelter. At this point, the home had been abandoned for quite some time. But when the kids ran inside, they were met with scents of lilac and lady's perfume, along with some whiffs of tobacco smoke. Their eyes met the vision of a beautiful blond-haired and blue-eyed lady, dressed all in white, in a portrait that hung over the hearth. As they looked, they noticed that the mysterious woman's complexion was radiant, as if a real living person was looking back at them, not an object like a painting. Her eyes were haunted but very alive, burning a stare right through them. As they all stood next to one another, they noticed that the sofas and chairs were pulled close up to the fireplace, and there were tables and crystal vases that decorated the fine dining room. As they stood there, it became apparent that this home was not abandoned at all. Where was the dust and the cobwebs? Who or what was living there?

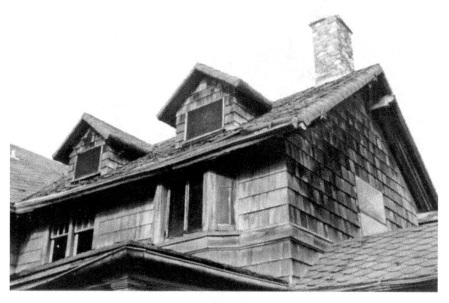

Upper shot of home, circa 1980s. *Courtesy of "OMW."*

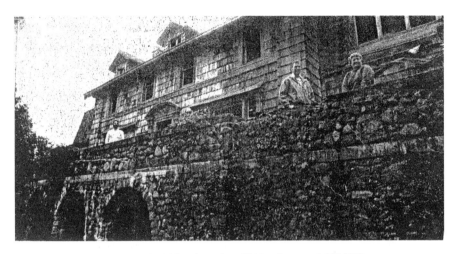

Exterior side shot, Summerwind Mansion, circa 1980s. *Courtesy of "OMW."*

They settled before the fire they had started, all huddled together, and when they were nice and toasty warm, they became restless. They decided to explore more of the mansion. Their explorations were met with gorgeous and expensive paintings along with very fancy furnishings. The children started to walk up the main steps, heading to the second floor, but froze in place when they heard soft footsteps behind them. They stopped and turned. Standing behind them was a beautiful woman wearing all white and looking at them with the most beautiful pair of blue eyes they had ever seen. But her eyes were so sad, and the children realized that they were face to face with the mysterious lady who was in the portrait on the main floor of the house. Then the ghostly woman smiled at them and vanished. As the kids were frozen in place, they all smelled the faint scents of lilacs and lavender. The spot on the steps where she had stood had a glowing light cast on it. After this incident, they realized that they had met with the ghost of "Miss Lucy." And this beautiful, yet sad, ghost became more than just another supernatural phenomenon—she became a kind of angel to the neighboring kids as well.

Reportedly, the old mansion became shelter for several more kids over the next few years. Just like Emily and her friends, all the other children met the infamous and sad but beautiful mansion ghost. Every time she was encountered, she was wearing white. On one occasion, some of the children started to run toward the front porch of the old home because a storm was brewing, but quite suddenly, Lucy appeared and was waving her

arms, motioning for them to get down. They all dropped to the ground, and just as they did so, shots rang out and bullets zinged over their heads. The caretaker of the place was intoxicated and shooting his rifle. If the ghost had not warned the children, they could have been injured or killed. Hollatz went on to say:

> Another time, several years later, some men were moving a piece of heavy equipment across a small bridge near Summerwind, when a woman dressed in an old-fashioned white gown appeared on the bridge, motioning for them to stop. They did. Upon further investigation, the bridge was found to have become weak. It would never have held the weight of the men and the machinery. It would have buckled, and they would have crashed to their deaths. Lucy had saved another pair of lives. Perhaps in vindication for being kept a prisoner in Summerwind, Lucy stays now to keep others from becoming tied to the place. In all accounts, Lucy is a sweet, sad looking woman wearing a white dress.

This begs the question: was she real, and if she was, what became of her?

Whether the story of Lucy is based on true events, semi-true events or is just plain made up, I think that fans or history buffs who take great interest in Summerwind and its legends will store this account with others stories that have been shared, passed down and now told to this day. Every location has a history, good or bad. Without history, there would be no ghost lore. I said that to my husband one day while we were out and about, and ever since, I have used this self-created quote. Without the history, such as events, people and how these situations and people all come together, any good or bad energy or paranormal phenomenon wouldn't or couldn't be created. These creepy tales, whether true or false, form another thread intertwined with the spool of history.

As for the mysterious lady in white that has actually been encountered at the mansion ruins over the years by legend-trippers, paranormal investigators, history buffs and the like wonder if she and Lucy are one and the same. I usually am skeptical about a legend of a place when I hear or read about a lady in white, just because it is so common and clichéd. With the questions of Lucy's existence being real and her supposed marriage to Robert P. Lamont, I dug a bit deeper into the "woman in white" phenomenon. This type of ghost is reported not just in the United States but all over the world, or so it seems. I found an online article titled "The Woman in White: A Legend," written by Krista Duranti.

According to Duranti, "The general term for this mythical creature is a 'White Lady.' It is also known as Woman in White or a Weeping Woman. A White Lady is a type of female ghost/apparition and is often seen in rural areas and associated with tragedy. The most common story behind this legend is that of a woman being betrayed by a husband and fiancé and then taking her own life." My eyes widened after reading this first paragraph of the article. I had heard about the "Woman in White" but was unaware of the details or specifics for this supernatural legend.

The sad story of "Lucy of Lilac Hills" fits the mold for the "White Lady" perfectly. Lucy was obviously female, she was living in a very rural area when at Summerwind and she had much tragedy in her life—more specifically, she was betrayed by her husband and treated harshly, to the point where she was kept a prisoner; after finally fleeing from his grasp, she got caught by him once again and dragged back to what was most likely hell on earth to her. Let's not forget the fact that she lost her baby girl as well, which brings more tragedy into Lucy's life. The only part of the legend that doesn't fit is the fact that Lucy was never reported to have taken her own life. This is one detail of the "Woman in White" that doesn't match. Krista Duranti went on to state, "These apparitions are often said to be harbingers of death. It is also often found under 'Ghostly Hitchhikers' and the like because in some stories, she is seen by the side of the road, waiting for unfaithful men to pick her up." The story of Lucy doesn't fit this part of the legend either. The one thing that kept pulling me in was the fact that she is reported as a beautiful woman wearing white, time after time, year after year. Lucy also does not fit the "harbinger of death" role either. If anything, she is the opposite, guiding others to safety when they are in harm's way but do not know it.

In any event, the story of Lucy has compelled me to share her story (whether it is factual or not) in this book. Whether she did indeed exist and was married to Robert Patterson Lamont, residing with him at Summerwind Mansion, this is cause for extreme speculation. Lamont had a wife, Gertrude, whom he married in 1894; it was reported that he built Summerwind for her and the children they had together. If Lamont had two wives, that would mean he was a bigamist, which isn't totally impossible but hard to believe somewhat just because of his very public reputation as being secretary of state. It may have been a bit more difficult for him to hide something like this than it would have been for the "common Joe," but I would never want to completely discount anything. With the paranormal, I have learned one thing: always be

skeptical, take everything in, do your research and go over the facts, and if there is something that stands out, research it again; after that, if you don't have any answer, then perhaps the legend or story/event is true.

If Lucy did indeed truly exist, my heart breaks for her. Her story is almost that of a fairy tale that goes horribly wrong, or perhaps the beautiful tragic female character/heroine in a Shakespearean play. I think maybe that's why it's hard to believe, but it's not hard to feel for her son, James, who was traumatized by both his father's actions and a haunted home, and the infant daughter Lucy, who was taken too soon from her mother's arms. At least her spirit is said to be a protector, and I find it ironic that she is just as giving in death as she was in life. The story of Lucy is about a woman who self-sacrifices to save the ones she loves. She does this by giving herself to a man twice her age and then accepts a marriage proposal to his son and moves far away from everything she knows. In death, perhaps she serves as a guardian angel of the Summerwind property, and if she sees anyone in danger, she lends a hand the best way she can. Truly, for a brave, giving ghost such as she, it is bittersweet to think that Lucy wants to save others from this prison she called home. Maybe she knows the "secrets of Summerwind," and if you're lucky, you will see the beautiful blue-eyed woman in white, motioning with her arms to turn away and never come back.

THIS OLD HOUSE

L ike many popular attractions, whether they are haunted or not, Summerwind Mansion has become subject to a lot of attention and also speculation. In November 1980, *LIFE* magazine came out with a spooky article titled "Terrifying Tales of 9 Haunted Locations." On pages 152 and 153 on a full-page spread is Summerwind. It was the first featured location and covered two pages for the creepy panoramic photo. At last this mansion was welcomed into the world and would beckon to individuals from across the country. Most Summerwind buffs know of this article and realize that this is how the old mansion was thrust into becoming a paranormal celebrity in its own right. Although the article was short, it left me feeling as though I had to learn more, and it's safe to say that others felt the same way after reading this:

> *Overlooking a lake in Wisconsin's north woods, Summerwind is a bat-filled, decaying mansion. The ghost of 18th century explorer, Jonathan Carver, in search of his deed to the land, succeeded in driving out a former Secretary of Commerce by sabotaging his wife's efforts to clean the place for guests—including President Harding. In 1970 a family of eight moved into the abandoned house. Within a year, the father had been driven mad by ghosts who demanded to be soothed by endless organ music and the mother had attempted suicide. The next owner found that newly hung wallpaper disappeared and not even six coats of paint covered the stained walls. No one lives there today, but Summerwind is not empty.*

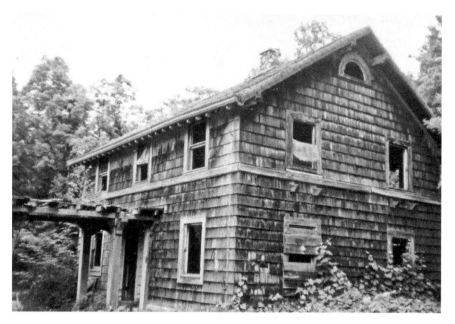

One of the cabins on the Summerwind property, circa 1980s. *Courtesy of "OMW."*

In 2005, Summerwind was featured on a Discovery Channel show called *A Haunting*. Just like the *LIFE* article, the old mansion was once again shoved into the spotlight, and this time, with the exposure of a popular paranormal show, the home's history and reported lore drew viewers in even more. I own the season of *A Haunting* and have watched the episode about Summerwind, called "The Haunting of Summerwind," many times. This forty-four-minute episode was a very captivating show and not only gives historical information but also interviews with some of the Hinshaw family who last lived there—plus there are some spooky reenactments. Until this show was released, all Summerwind enthusiasts had were articles, books and old photos, so I think that is some of the reason why "The Haunting" episode about Summerwind was and still is so popular. Suddenly, Robert P. Lamont and his family came to life before the watcher's eyes, the ghosts reported to inhabit the home flashed across the screen and it all left people wanting even more—almost craving to experience some of these happenings for themselves. To give credit where credit is due, the person who truly put Summerwind "on the map" was Raymond Bober. His 1979 release of *The Carver Effect* sparked the initial interest in the legend of British explorer Jonathan Carver

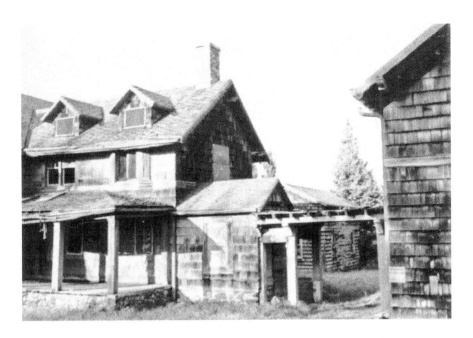

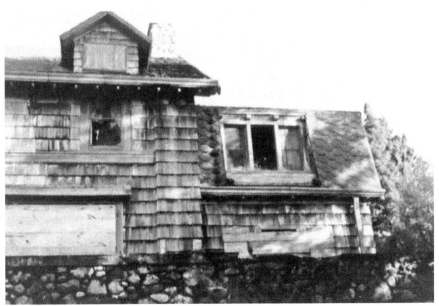

This page: Exterior shots of mansion, circa 1980s. *Courtesy of "OMW."*

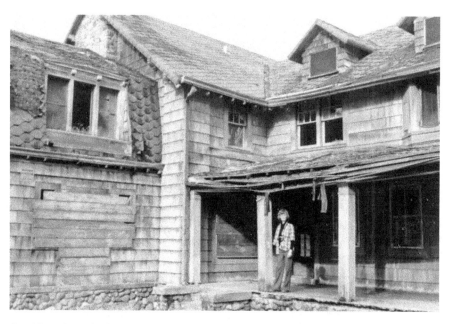

Outside and porch of depilated mansion, circa 1980s. *Courtesy of "OMW."*

and his mysterious connection to the old mansion by the lake. Bober's terrifying experience touched many of his readers, and the *LIFE* article plus *A Haunting* just fueled the flames even more.

Many books have been written over the years regarding the tale of Summerwind. Nothing has been along the lines of *The Carver Effect*, yet most paranormal authors who write books on reportedly haunted locations in the state of Wisconsin include Summerwind, and rightfully so. The ruins have definitely moved up the ranks and deserve their place in haunted history, especially in the state of Wisconsin. Paranormal investigators/authors Chad Lewis and Terry Fisk wrote the definitive guide to all places spooky in the state of Wisconsin. In 2004, they released *The Wisconsin Road Guide to Haunted Locations*, and Summerwind was featured in this book. In 2010, author Linda Godfrey followed suit and wrote the book titled *Haunted Wisconsin: Ghosts and Strange Phenomena of the Badger State*. The two books with the most information (both historical and paranormal) and written by the same author, Tom Hollatz, are *Campfire Stories* and *The Haunted Northwoods*. When surfing Amazon.com, I found a book that was released in 2014 called *Summerwind* by Dwayne Fry. This book is loosely based on some of the lore and tales; however, it

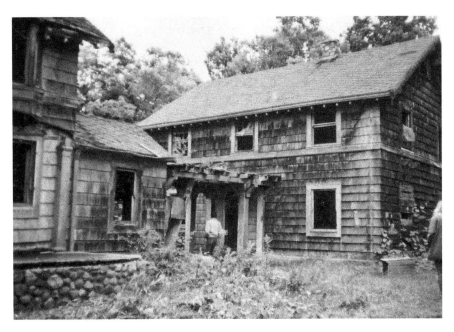

Exterior shot of the house and one of the cabins, circa 1980s. *Courtesy of Adam Bauer.*

is fictionalized and takes a slightly different turn. This is the description of the book according to what is on Amazon.com: "Summerwind is the home of Maxwell Shaw and his wife Alicia built for themselves. They lived there in peace and harmony with their daughter Haylie, until a tragedy took Alicia and Haylie from Max. It's now nearly two years later and Max has remarried and is moving his new wife into Summerwind. They are looking forward to a few days being snowed in and enjoying their newly married bliss, but things begin to grow somber when Max finds that Summerwind is now haunted by his daughter." This reminds me of the book *Rebecca*, by Daphne du Maurier, written in 1938. It is a story of a man named, ironically enough, Maximilian or "Maxim" de Winter, who has lost his wife, is in Monte Carlo and meets a young woman whom he eventually marries and takes back to his manor. After his wife starts trying to settle into the home and her new and somewhat overwhelming title of "Mrs. de Winter," the sinister housekeeper, Mrs. Danvers, starts to convince the young wife that Maxim's first wife, Rebecca, is still in the home and does not want her there. I can see a somewhat similar take in the general description of Fry's book, *Summerwind*, but instead of the home being haunted by the wife, it is haunted by his dead daughter.

In any event, any Summerwind enthusiast should give this book a try. I know I will!

About a year ago, I got a huge chuckle from the '80s/'90s sitcom *Roseanne*. I love seasons one and two of this show in particular, and in season one, very early on, there is an episode called "The Monday Through Friday Show." The basis of the episode is that Dan and Roseanne Connor butt heads because they never originally had a honeymoon after marriage, so they both decide to pick their own spot and then see which place they will go to. Roseanne picks a tropical paradise in Florida, and Dan picks "the Lamont Cabins on Boulder Lake in Rhinelander, Wisconsin." We have the Lamont Cabins, aka the Lamont Mansion, Boulder Lake instead of Boulder Junction where the ruins are close to and, finally, the Northwoods of Wisconsin. The connection is uncanny, and whoever helped or fully wrote the script knew something of the old mansion and the location. I had seen this particular episode several times, but once I gained knowledge of Summerwind, when I happened to watch it, I couldn't believe it. I had quite the laugh because it was a very clever way to mention such a notorious location in a very indirect manner.

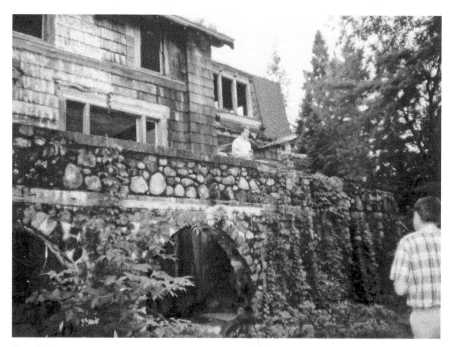

Shot of stone terrace, circa 1980s. *Courtesy of Adam Bauer.*

I visited the "Winchester Mystery Mansion," located in San Jose, California, back in 2002. I learned the history of the rich eccentric lady who built the home, Sarah Winchester. She would have séances frequently and claimed that the spirits told her to keep adding on to and building the home bigger and bigger. There are areas in the home that do not make any sense, such as a staircase that leads up to the ceiling and simply stops. This reminded me of a Stephen King novel titled *Rose Red*; it, too, featured a manor or large estate where the lady of the home was involved in supernatural occurrences. The legend of "Rose Red" also had unexplained dimensions, as some rooms would shrink and others would become bigger and no one could explain this activity. With Summerwind, this lore is also attached, and some have stated that the blueprints did not match up to some of the rooms after the fact; however, when it was constructed, it was done properly without error.

Some have claimed that these expanding or diminishing rooms are a result of paranormal activity. Again, the legend of the "Winchester Mansion," Stephen King's book *Rose Red* and the connection to Summerwind and its odd-shaped rooms all tie together just like the legend of the Amityville Horror. Some speculate that these legends regarding Summerwind were nothing more than someone hearing of the other popular locations and applying certain tales from them to the old Lamont Mansion. Once again, with the paranormal, there are no certainties and straight answers, and that is part of the magical and at times unnerving story of some of these places. It keeps people on their toes and constantly hungry for more.

THE DEATH OF SUMMERWIND

On Father's Day 1988, there was a very violent thunderstorm that ripped through the Land O' Lakes area. The storm was so unrelenting and fierce that some compared it to the story of Noah's ark with all the rain that fell that night. One could think that maybe this storm targeted the dilapidated old mansion, and once the grounds were in its sight, there was no going back.

Some say it was lightning that came down and struck the old home. Because of the dry, rotted wood, the old house was a sitting duck for a storm such as this. In an article in the book *Campfire Ghost Stories*, it is noted that "a fire Sunday that destroyed the Lamont mansion, one of Wisconsin's most notable haunted houses on West Bay Lake here, is likely to have been started by lightning, according to a fire department official." The fire chief, Sam Otterpohl, stated that due to the massive amount of lightning, it was completely plausible that this was what brought about the demise of Summerwind. However, it was a popular location and had a sordid reputation, so in the minds of many, the question of arson has lingered. Thinking about the fire being set purposely, it does seem plausible that perhaps a person or persons acted as sort of vigilantes and decided that the home was evil and had to go. Like many intriguing mysteries that are never solved, I believe Summerwind is one of these legends.

Hollatz went on to state in this book, "The fire chief said the department was called to the scene at 7:55 a.m. and the main building was already engulfed in flames." At the time of the fire, the home had three owners:

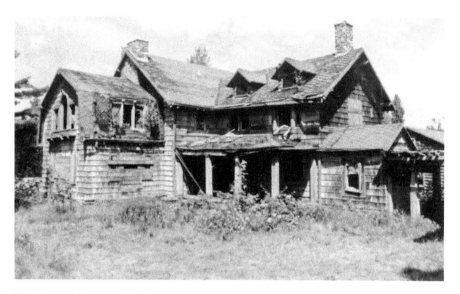

Full photo of Summerwind Mansion, circa 1980s. *Courtesy of "OMW."*

Harold Tracy, Jerry Olk and Roger Pfohl, and they all purchased the property in 1986 from the Lillian Keefer estate. The plan behind the purchase was to turn the home into a bed-and-breakfast inn. But that was never to be…or was it?

When the smoke cleared, the only remnants of the mansion were the two tall chimneys, the crumbling stone terrace and some charred beams that gave testament to the violent death Summerwind experienced. Over the years, the draw from these ruins has grown in popularity. Maybe it's because of the rumors, and maybe it's because of the intrigue of the area in general, but I think it's simply because the former home appears in such a state of shock, with its two chimneys reaching up to the sky with strong, sturdy arms. This gives the grounds a creepy look whether during the day or night, during the winter or summer. I never got to visit the former home when it still stood, as a rotting shell, but I can tell you this. I'll bet that now that the house is no longer standing, it appears even more ominous and larger than life. Some colorful graffiti adorns the stone archway, what's left of the terrace and what innards are left from the former cabins that used to sit to the side of the home. To the artist in some, this appears to be a colorful palette, but to an angry spirit or two, maybe not so much. Many have stated that with the partiers and legend-trippers who have graced the grounds over the years, they in turn helped with the "demise of Summerwind" before it burned down. The

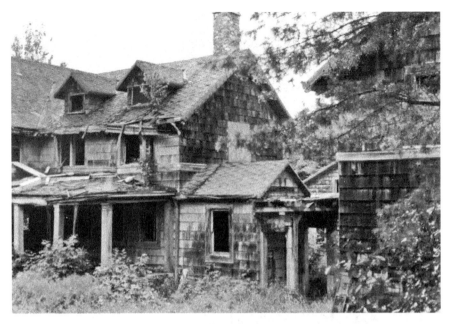

Exterior shot of mansion, circa 1980s. *Courtesy of "OMW."*

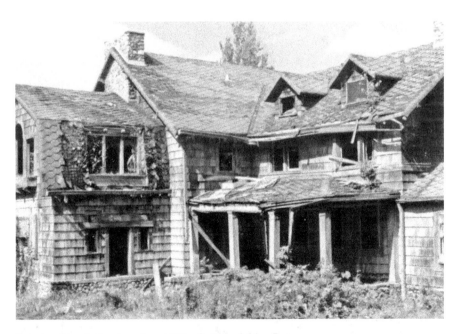

Exterior shot of mansion, circa 1980s. *Courtesy of Adam Bauer.*

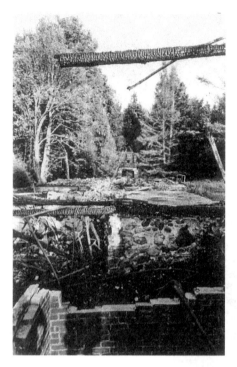

Left: Summerwind Mansion after the fire. *Courtesy of Adam Bauer.*

Below: Stone terrace and chimney, 2010.

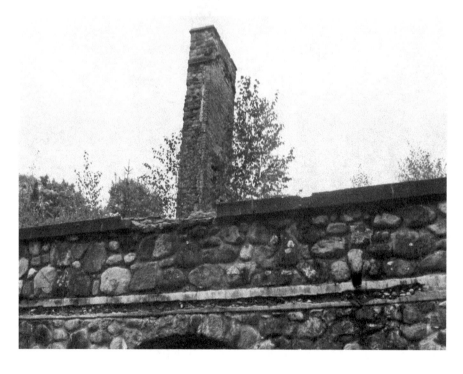

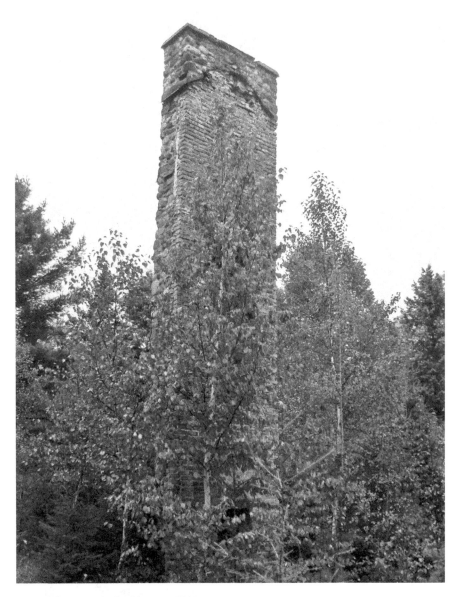

One of Summerwind's chimneys, 2010.

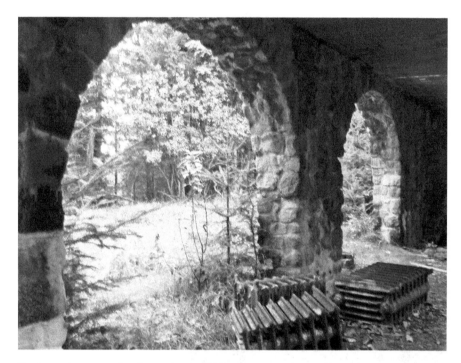

Underneath terrace, showing archways, 2010.

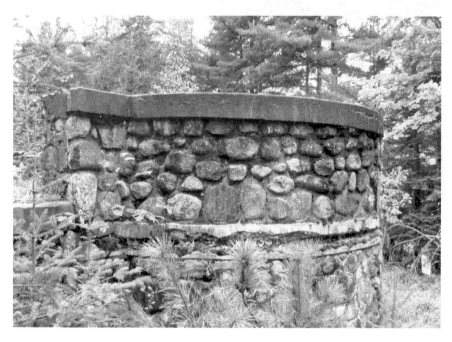

Photo of stone terrace from below, 2010.

home was in such a state of disrepair not only from people traipsing around but also from the bitterly cold and harsh Northwoods winters it had to endure every year. And with all the spook hunters, paranormal investigators and passersby who on a whim decided to track down the former mansion, the alluring draw of Summerwind continues and will probably most likely continue for many years to come.

The doors to this mansion are now open 24/7 (with permission from the owners of course), but even though all that's left are skeletal remains, would you welcome them with open arms? Do you dare to embrace the corpse of this former home?

SUMMERWIND IN THE MEDIA

The story of Summerwind Mansion, including the history and different lore, has been circulating for years now. What made the old mansion step into the spotlight was most likely when the popular Discovery Channel show *A Haunting* decided to air an episode about the house. The episode, called "The Haunting of Summerwind," was aired on November 5, 2005, and took Summerwind to a whole new level. Now viewers could see this ghost lore come to life before their very eyes, and it left the public hooked and hungry for more. Many have since visited the site, and paranormal groups have conducted their own investigations. For the many different persons who visited when the home still stood, the younger generations were now wanting to uncover the secrets that stood now skeletal and in ruins. With *A Haunting*, Summerwind was thrust into the limelight, and sometimes I wonder if the spirits are basking in the fame or resentful of it.

I came across a story online of a man's father who in 1981 decided to visit the then standing mansion with four of his co-workers. They arrived around midnight, and one of his friends had a dog with him. The dog refused to get out of the vehicle and walk up to the abandoned house. The poor dog was obviously upset and continually whimpered, leaving the group wondering what was upsetting him so much. Reluctantly, they decided to leave the dog in the jeep and began walking up to the old mansion. The writer stated that his father told him that the spontaneous visit was pretty dull and nothing scary really happened. But a few years

later, his father and his father's girlfriend (whom he later married) were snowmobiling and found themselves heading over to the snow-covered mansion. When they got there, they had this ominous, strange feeling that they should not be there. His father looked up to the second-story window, where there were old dusty curtains, and saw them move slightly. As he peered at the window, he saw a white ghostly face that looked right at him and then slowly moved the curtains back to their original state. They never returned again.

I found another statement by a person called "Jim" on a website called Haunted Places:

> *My son visited there with a group of friends last summer. He has a very strong Christian faith and as he stepped over the cable blocking the driveway and set foot on the property, he began heaving uncontrollably. Out of nowhere and with no warning, he was sicker than a dog. They did not continue and returned to the car. Once away from the property, he felt fine. Everyone was totally freaked out!! He said you could feel the evil presence! My wife and I are visiting this Friday, just before Halloween. We'll see what it brings us!*

This reminds me of when my friend and intuitive Wendy became almost violently ill when we visited the property several years ago. Now I wonder if people who are "sensitive" or have some sort of otherworldly intuition have this reaction to the ruins because there is actually evil present.

Stories such as these have spread and made Summerwind so reputed and popular. A woman by the name of Jennifer had read up on the stories, so she decided to visit and investigate Summerwind for herself. In her article from 2009, she goes into the history a bit as well as the Discovery Channel show and, finally, finding the ruins. She stated that while there, she and the people she was with didn't encounter anything out of the norm, but when they got home and decided to analyze photos they had taken, they were shocked. When they were able to enlarge one of the pictures, they noticed a ball of light or orb under the arch that still stands. Jennifer's mother also claimed to have seen a man in one of the photos as soon as she looked at it, and it startled her. The man was so clear in this photograph that they were able to make out the color of his skin, the hairstyle and color/style of clothing. They came to the conclusion that he must have either been a former resident or a spirit that perhaps visited when the mansion stood and has not left in death. She even looked at some

photos of the original owner, Robert Lamont, and saw no resemblance. About a year later, Jennifer was watching television and caught the episode about the mansion on *A Haunting*. She learned that the house has a hold over certain people and sort of "calls" to some individuals, and this left her wondering if Summerwind had called to her husband in his dreams because he claimed to have had some odd dreams of the house that led them to visiting for the first time.

Many paranormal teams have since investigated the house ruins and posted on their websites about their findings. A team called PROPHET out of Minnesota visited the remains of Summerwind on July 5, 2008, and took many different readings and photos while there. When perusing its website, I read about some of the results from the investigation, including two popping sounds on the digital recorder that they described as "ghostly gunshots." They also captured an unexplainable haze while videotaping an area, and lastly, a few of the photos they took had what appeared to be orbs. They left their findings open-ended and talked about wanting to go back and further explore the grounds and any interferences that could have occurred during the investigation.

Summerwind enthusiast Todd Roll, who took the now famous "bullet holes in the door" photo, was able to explore the mansion when it was still standing. I was recently in contact with him, and he shared his unnerving experience:

> *I was able to visit Summerwind three times in the early 1980s before it was struck by lighting and burned down in the late '80s. On my second visit to the mansion, I experienced something that I could not just explain away as some mundane event. On that particular trip in early spring of 1986, I was alone on the second floor in the small hallway that lead to the master bedroom. There was a bathroom off this hallway, and I decided to walk in to have a look around. When I crossed the threshold to the bathroom, I was overcome with a feeling of dread. The hair on my arms stood up, and the adrenaline started pumping through my system and a massive fight-or-flight response kicked in. I immediately left the bathroom and moved back into the main second-floor hallway. The feeling of dread left in a matter of seconds, and I returned to the bathroom doorway and steeled myself for another go at the room. Once again I crossed the bathroom threshold, and I was overcome by dread. I stepped out of the room and called to the other investigators in the mansion to join me on the second floor. I asked each of them to enter the bathroom*

to determine if they would have the same reaction that I had; however, neither investigator had the same sense of dread I had experienced. During my two other visits to the mansion, I had no problem entering the second-floor bathroom—the sense of dread was gone. Still can't explain what happened that particular day at Summerwind. I hadn't experienced such a visceral reaction before nor after my visit to Summerwind in 1986 and have wondered if I was tuning into some traumatic event that took place in the second-floor bathroom.

There have been many other investigative teams that have had the courage to delve into the secrets and supposed activity at the derelict mansion. As this area has become more and more popular, many have flocked every year from all over the world to visit the famous mansion ruins. It's ironic and so true, but Summerwind is more alive in death than in life. I suppose that can be said about many reportedly haunted locations. Just type in the mansion's name on sites such as YouTube, and many videos will pop up. Some are videos of legend-trippers, others are slideshows that talk about the history and ghost lore and there are also some from paranormal investigators capturing their visits and findings on film for everyone to see.

Many authors have written about Summerwind in their books. Author Linda Godfrey covered the mansion in her book *Haunted Wisconsin: Ghosts and Strange Phenomena of the Badger State*. In 2013, author David Pietras wrote a book called *Top 10 Most Haunted Places in America* and paid homage to the old mansion as well. You can find the history and lore, plus how to get to Summerwind, in the book from 2004 titled *The Wisconsin Road Guide to Haunted Locations* by Chad Lewis and Terry Fisk. Last, but not least, a very important book that was and will always hold a certain energy of its own is *The Carver Effect* by Wolffgang Von Bober. It was Bober who really put Summerwind on the map of the paranormal, and in my opinion, he is the founding father who sparked the interest in many, including myself.

Since Bober's book, numerous paranormal investigators, legend-trippers and history buffs have been and continue to be drawn to this ominous yet endearing site of the ruins of what was once a sprawling estate. I guess this makes Summerwind a celebrity of sorts, and I think it will continue to awe and compel people for years to come, wanting to find that one secret, ghost, ball of light, story or supernatural whisper in their ear that will symbolically unite them to the old home forever.

RISE FROM THE ASHES

To rise, first you must burn.
—Hiba Fatima Ahmad

Just like the age-old tale of the strong and mighty phoenix rising once from the ashes, Summerwind may see itself in all its glory again. Perhaps sometimes buildings have to burn to be reborn, and Summerwind now fits that mold. Many fans who have been transfixed and lured in by the elusive Summerwind property and stories have stated time and time again that it would be wonderful to see it built again—to be better than ever. Some have wanted to rebuild it as a home for themselves, some have wanted to make it a resort and others have thought that rebuilding and making it a sort of bed-and-breakfast would be a wonderful idea. And then there are some who think that we should learn from history. Perhaps there is a reason the old derelict mansion burned to the ground. It may be a sign that the grounds are cursed or there are restless spirits that remain and have taken the property back in the only way they can. Then again, maybe some of learning from our history *is* to repeat the same mistake twice. If this should indeed be the case, perhaps everything will turn out peacefully—Summerwind Mansion will continue to prosper and be alive again as it used to be. Just as the quote by Hiba Fatima Ahmad states, "To rise, first you must burn," perhaps the home had to burn and then be blessed with a second chance.

Some skeptics or superstitious people may think that if it is rebuilt, things will go horribly wrong and the mansion will entrap others the way it did

so many years ago, drive them mad or suicidal or haunt their minds and lives forever. Then there are others who simply say that this house was never haunted. An article from the *Milwaukee Journal* from October 21, 1985, featured interviews with several local residents. A man named Gene Knuth, who had lived in the area for sixty years, said that the home was never reported to be haunted until it fell vacant for a long duration of time, hence falling into disrepair. Once this happened, the rumor was started that it was allegedly haunted. Carolyn Ashby lived in the mansion in the 1940s as a child and stated that, yes, it was creepy at night due to all the rooms, but she never saw or heard anything that would have led anyone to believe that it was haunted.

Is there any truth into the "Summerwind Curse?" Some will say yes, that they experienced it firsthand. I have read countless stories about individuals who took souvenirs from the ruins and then had a string of bad luck. Coincidence? Maybe. But would you want to risk it? This scenario reminds me of cursed objects, which can vary from dolls to a portrait or even an article of clothing. For some unexplained reason, these objects carry some

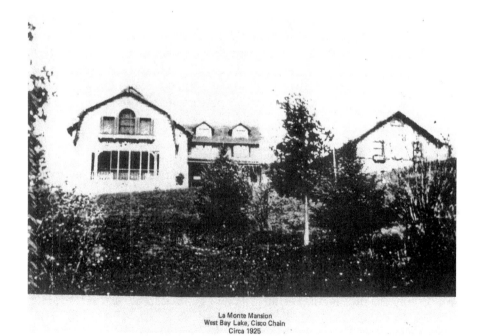

La Monte Mansion
West Bay Lake, Cisco Chain
Circa 1925

LaMonte Mansion West Bay Lake, Cisco Chain, circa 1925. *Courtesy of Adam Bauer.*

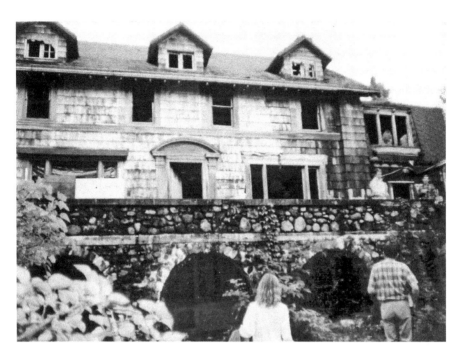

Looking up at the stone terrace and mansion, circa 1980s. *Courtesy of Adam Bauer.*

curse, and once someone comes into contact with the item, until they are rid of it, bad things will happen. Is it possible that the ruins of Summerwind Mansion are cursed objects? When the house still stood, were the items like furniture cursed as well?

I guess in the end, we just have to either take that chance or leave it alone and let nature continue to claim the remains forever. Whatever you think, I'm sure the old Summerwind ruins have their own agenda, as they always have had all these years. I will leave the choice up to the reader because in the end, no matter what the future fate of Summerwind is to be, it's up to you, nature and just maybe Summerwind itself to make the final decision.

BIBLIOGRAPHY

Allison, Andrea. *Paranormal Stories* blog. http://paranormalstories.blogspot. com/2014/08/summerwind-mansion.html?m=0.

Angelfire. "Summerwind." http://www.angelfire.com/ca4/boknows/ Summerwind.html.

Bernier, Callie Jo. "Eternity in the Northwoods: Summerwind." Mr. Strong's class, December 22, 2006.

Daily Motion. "A Haunting: The Haunting of Summerwind." Discovery Channel, 49:00, November 4, 2005. http://www.dailymotion.com/ video/x24zswg_a-haunting-s01e02-the-haunting-of-summerwind_travel.

Falch, Sara. "Jonathan Carver's Footprints: The Carver Land Grant Case of 1825 and the Impact of American Indian Policy." Master's thesis, University of Wisconsin–Eau Claire, 2008.

Fisk, Terry, and Chad Lewis. *The Wisconsin Road Guide to Haunted Locations*. Eau Claire, WI: Unexplained Research Press, 2004.

Fry, Dwane. *Summerwind: A Haunted House*. N.p.: Amazon Digital Services, 2014. http://www.amazon.com/Summerwind-haunted-house-Dwayne-

Fry-ebook/dp/B00OFR1954/ref=sr_1_1?s=books&ie=UTF8&qid=14 45414826&sr=1-1&keywords=summerwind+mansion.

Genealogy Inc. "Vilas County." http://www.genealogyinc.com// wisconsin/vilas-county.

Ghostly Wisconsin blog. http://ghostsofwisconsin.blogspot.com/2012/03/ summerwind.html?m=1.

Ghost Mysteries. http://www.ghost-mysteries.com/viewstory.php?id=8704.

Godfrey, Linda S. *Haunted Wisconsin: Ghosts and Strange Phenomena of the Badger State*. Mechanicsburg, PA: Stackpole Books, 2010.

Hard, Anne. "Guide of America's Trade." *New York Herald Tribune*, April 14, 1929.

Haunted Places. "Summerwind: Lamont Mansion." http://www. hauntedplaces.org/item/summerwind-lamont-mansion.

History.com. "Carpetbaggers and Scalawags." http://www.history.com/ topics/american-civil-war/carpetbaggers-and-scalawags.

Hollatz, Tom. *Campfire Ghost Stories*. Wautoma, WI: Angel Press of Wisconsin, 1990.

————. *The Haunted Northwoods*. St. Cloud, MN: North Star Press of St. Cloud Inc., 2000.

HubPages. "The Woman in White: A Legend." http://kduranti.hubpages. com/hub/The-Woman-in-White-A-Legend.

Jack MC blog. http://midwesternghostsandhauntings.blogspot. com/2011/10/spirits-of-summerwind-mansion-west-bay.html?m=1.

"Kitty." "The Haunting of Summerwind: A Frightening Haunting in Wisconsin." *Kitty the Dreamer* blog. http://kittythedreamer.hubpages. com/hub/The-Haunting-of-Summerwind-A-Frightening-Haunting-in-Wisconsin, June 4, 2013.

Land O' Lakes Historical Society. http://landolakeshistory.org/index. php?id=45.

Milwaukee Journal. "He Heard Gunshots but No One Was There." October 21, 1985.

New York Times. "Rites for Robert Lamont." February 22, 1948.

———. "Robert P. Lamont, Hoover Aide, Dead." February 21, 1948.

Savannah Rayne's blog. http://savannahrayne.blogspot.com/?m=1.

St. Louis Post-Dispatch. "Robert Lamont Dies; In Hoover Cabinet." February 20, 1948.

Travel Creepster. "Summerwind." http://www.travelcreepster.com/ summerwind-travelcreepster.html#.UknrR4YqifI.

Van Goethem, Larry. "Haunted or Not Haunted, House to Be Razed." *Milwaukee Journal*, February 11, 1985.

Von Bober, Wolffgang. *The Carver Effect: A Paranormal Experience*. Mechanicsburg, PA: Stackpole Books, 1979.

What Did I See? http://yeti-whatdidisee.blogspot.com/2009/06/in-search-of-elusive-summerwind.html.

Wikipedia. "Robert P. Lamont." http://en.m.wikipedia.org/wiki/ Robert_P._Lamont.

———. "Summerwind." http://en.m.wikipedia.org/wiki/Summerwind.

Wundrum, Bill. "Haunted House Keeps Visitors Wondering." *Quad-City Times*, October 28, 2007.

———. "Summerwind: More Ghostly than Ever." *Quad-City Times*, October 29, 1995.

ABOUT THE AUTHOR

Devon Bell currently resides in Eau Claire, Wisconsin, with her husband, Tony. Devon, alongside her husband, is co-owner of the Haunting Experiments, which has put out many historical/paranormal documentaries, including a hit web series called "The Haunting Experiments Web Series." She is a paranormal researcher and writer, having also directed several different video projects, including a full-length paranormal/historical documentary titled *Caryville: A Documentary*.

Along with the paranormal, Devon has also written and directed a full-length feature film, along with other short films. She is a lover of music, has been involved with numerous musical theater shows and has also sang at several weddings, as well as spending some time in a few recording studios. Devon is a lover of Andrew Lloyd Webber's hit musical *The Phantom of the Opera* and is an avid collector of memorabilia for the show. Another passion is collecting historical/period costumes—every day is Halloween at the Bell house! She also has a blog, where she writes about all her hobbies and anything she wants to share with others.

Mrs. Bell has always been fascinated by the strange and unusual and also intrigued with history. Now with five books under her belt, the interest keeps growing, and she can't wait to share more stories with readers in the future. Devon feels that through preserving both the historical and the paranormal, there will be so much more to offer future generations to come.

Printed in the USA
CPSIA information can be obtained
at www.ICGtesting.com
CBHW071807210624
10449CB00005B/553